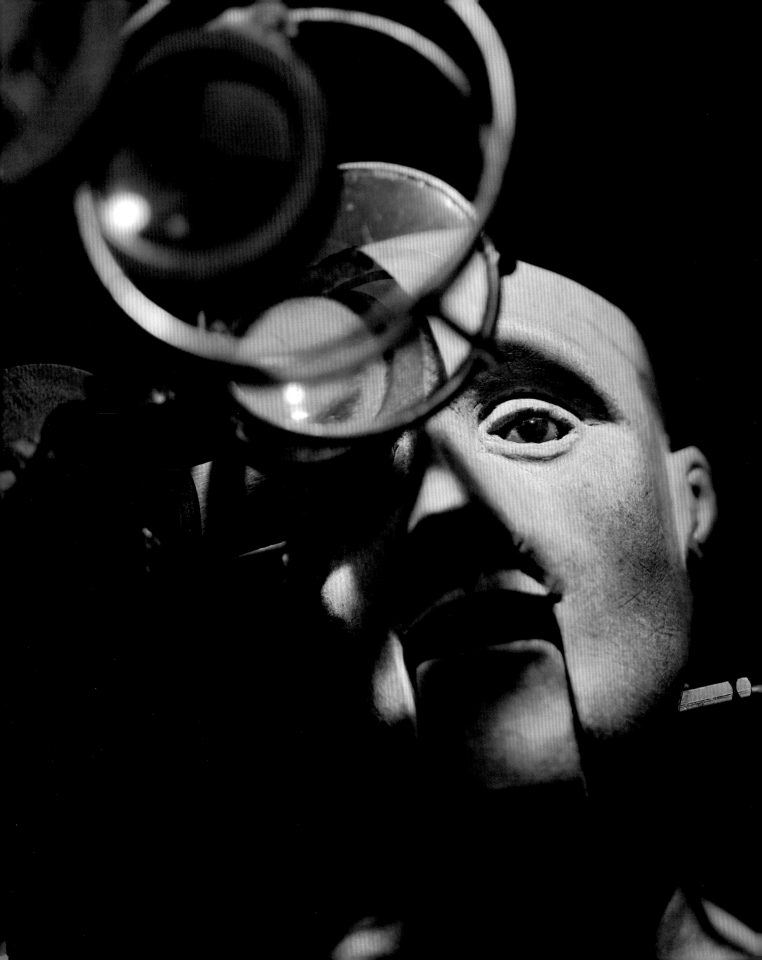

THREE FRAGMENTS
OF A LOST TALE

Sculpture and Story by John Frame

The Huntington Library, Art Collections, and Botanical Gardens
San Marino, California

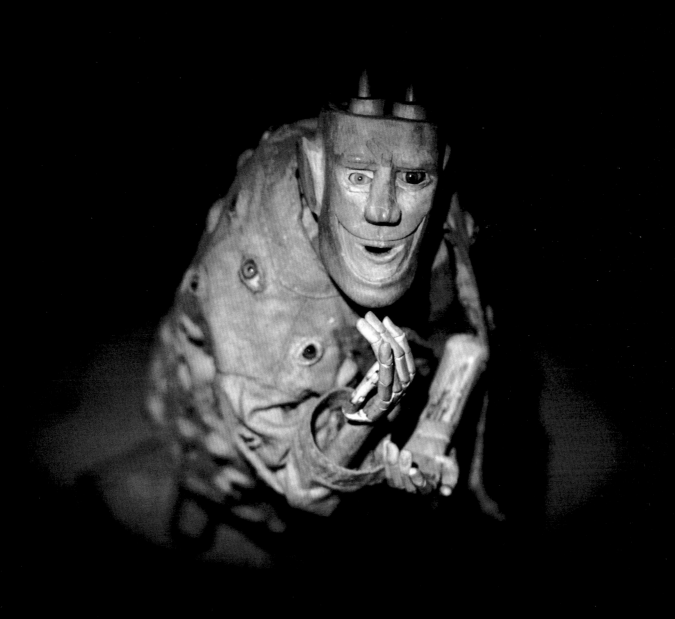

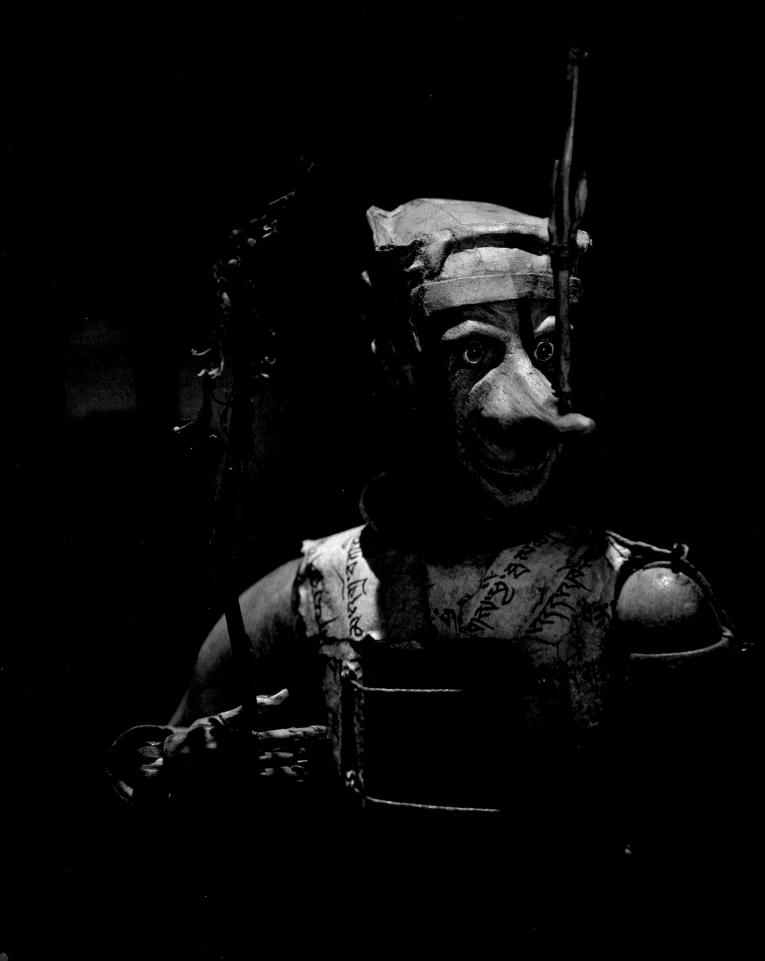

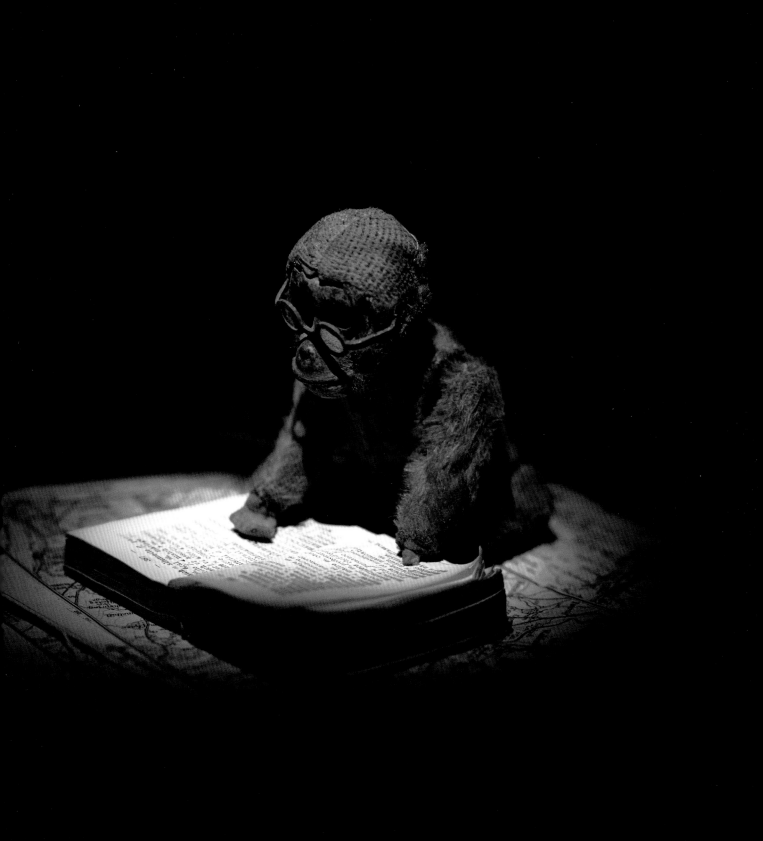

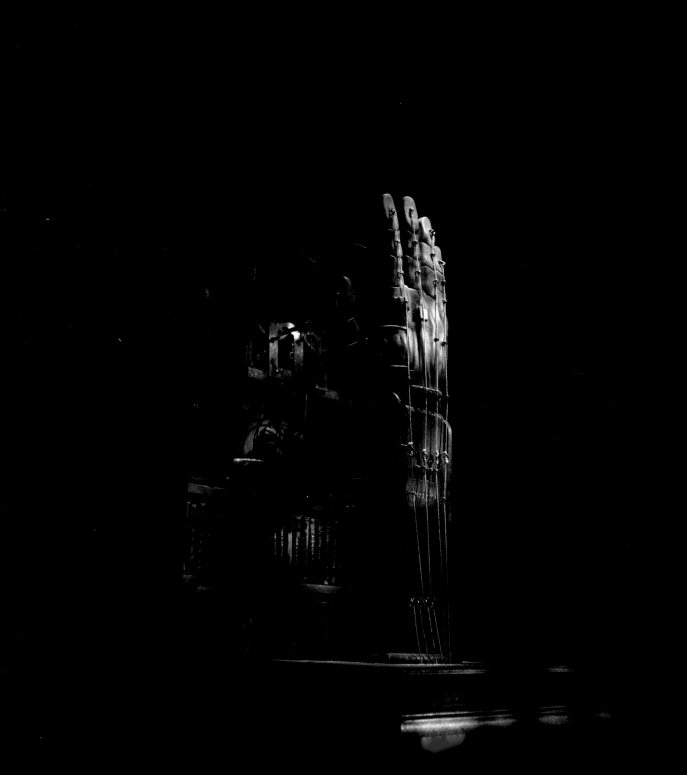

CONTENTS

12 Preface

14 Introduction
 by Kevin M. Murphy and Jessica Todd Smith

18 The Handmade Imagination of John Frame
 by David Pagel

30 Plates

110 Cast of Characters

PREFACE

This book is dedicated to the memory of George Boone, who was deeply interested in the work of John Frame even before Frame began developing the present project, *Three Fragments of a Lost Tale.* For some time the project remained confidential, known only to a small circle around the artist, which included George and MaryLou Boone. It was through George that the Huntington was made aware of it, when one day he arranged for John to come down from the mountains and show Jessica Smith and myself some of the mysterious figures that he had been working on. To us it was instantly clear that the project as he explained it, and the artefacts thus far produced, would make up an exhibition perfectly suited to the Huntington, where literature and art exist side by side, and where scholars engage imaginatively with the science, art, and technology of the past, through our collections, every day. We were delighted that John Frame agreed with our view, and it is a pleasure to record that the experience of working with him over the last four years, as the project developed in wonderful and unexpected directions, has been very exciting. All my colleagues extend their warmest thanks to John for his good humor, for his ready understanding of the practicalities of organizing exhibitions in museums, and for his willingness to solve any problems, usually by taking the burden on himself.

As well as the exhibition curators Jessica Smith and Kevin Murphy, exhibition designer Stephen Saitas, and all the staff of the Huntington Art Collections, I want to thank Susan Turner-Lowe and her colleagues in our Communications office for their creative role in producing the short film "Happy Medium" which shows the artist at work, and which establishes the presence of the exhibition on the internet. I also thank Sara Austin for her editorial work on the exhibition texts, and Martin

INTRODUCTION

Fox for editing the material collected in this book. We thank David Pagel for his sensitive and searching essay; and collectively we thank Marquand Books for producing a beautiful catalogue, with printed illustrations that do justice to the artist's own original photography.

John Frame himself adds:

At various points along the way, my daughters Lily Frame Coffeen, Ashley Fennell, and Katie Frame Coleman have provided specific help in several areas, including work on costumes, photography, and text editing. Carey Haskell provided invaluable assistance in many aspects of the photography, including final editing. I would like to express my special thanks to Ann Harmsen for helping me to get back on track at a particularly difficult moment in the creative process. In addition to his excellent work on the short film, "Happy Medium," Johnny Coffeen assisted with much of the animation and was the primary editor of all of my films. My wife Laura's assistance has been woven throughout the entire endeavor. Without her constant help and support this project could never have come into being. Most of all, however, I am grateful to George and MaryLou Boone for their interest in my work, and for their understanding of this project almost from the first moment of its conception. Such sympathy is rare in the contemporary art world, and without it this exhibition and book would have been impossible.

JOHN MURDOCH
Hannah and Russel Kully Director, Huntington Art Collections

F or over thirty years, John Frame has been creating figurative sculpture that explores the human condition. Since 2006, he has been concentrating on the body of work included in *Three Fragments of a Lost Tale: Sculpture and Story by John Frame*, an exhibition at the Huntington Library, Art Collections, and Botanical Gardens and the subject of this book.

Frame is an avid reader with broad interests, whose work relates in diverse ways to the collections of the Huntington—from his affection for William Shakespeare and William Blake to his immersion in the ideas of Arts and Crafts theorists such as William Morris. In fact, he has said that his thinking about the process of making art is best expressed by a quotation from John Ruskin: "Fine art is that in which the hand, the head, and the heart of man go together."[1] In that spirit, Frame has described his system of art-making as a triangle. At one point are things intellectual, at the second point are all of the technical elements, and at the third are what he considers to be emotionally authentic experiences. Those three elements are woven together by intuition, which rests at the center of that triangle.

The "three fragments" of the title refer to sculpture, story, and animated film, which form in turn the immediate physical, textual, and cinematic manifestations of a larger narrative John Frame has titled "The Tale of the Crippled Boy." The inception of the tale and its three elements came to Frame in a flood of inspiration that compelled him to sketch aspects of the story, figures, and animation in one sitting. Frame conceives of the three fragments as independent works of art that do not rely on one another for meaning and that should be appreciated

on criteria inherent in their respective media. The animated film, for example, shares with the story a temporal component as it unfolds over time, whereas his sculptures can be observed by the viewer more immediately.

"The Tale of the Crippled Boy" is epic in scope, non-linear in its structure, and shadowy in conception. In keeping with the work John Frame has created throughout his career, the tale and the art associated with it evoke universal human themes—the nature of good and evil, the inevitability of death, and the struggle to find meaning in life—but always in a connotative rather than denotative manner. Frame acknowledges that the tale is by no means complete, and its entire scope remains somewhat *terra incognita* to him. In its present form, it concerns a civilization in a time and place that Frame has suggested resembles a vision of the future as imagined by someone living in the sixteenth century. The civilization has experienced a great catastrophe and as it rebuilds, there is a desire to resurrect its greatest cultural achievement—a kind of illuminated glass that glows with an almost spiritual light. The art of making this glass was lost during the upheaval, and only the Crippled Boy, who had been a factotum in the workshop, still possesses the knowledge to produce it. The boy went missing during the cataclysm, and a cast of characters has assembled to locate and return him to the atelier. Many of the searchers—along with the Crippled Boy himself—had been part of a traveling acting troupe that had performed morality plays in the time before the catastrophe. The exhibition features representations of the Crippled Boy in several incarnations, those who search for him, figures related to the acting troupe—which originally included God and the Devil as actors who played themselves—theatrical sets, and a large stage on which Frame films them all.

Frame considers the tale to be raw material for his sculptures and film, likening it to the wood from which he creates objects, but it is not the object itself. Although the content of the tale may suggest ideas for the sculptures, their final form is dictated by visual, emotional, symbolic, or structural properties Frame finds in his materials, as well as through his highly intuitive working process. The movement and interaction of the sculptures when filmed are similarly determined by Frame's understanding of the finished piece and its relation to other works, rather than as a deliberate attempt to illustrate the tale.

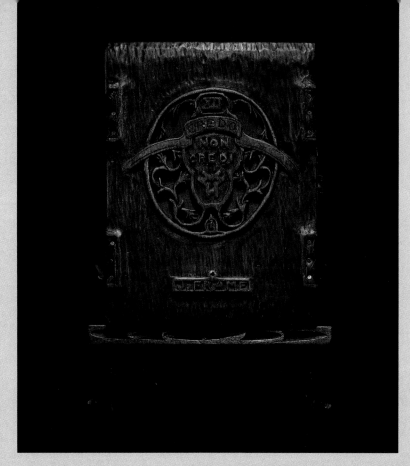

CREDO NOTEBOX FRONT VIEW

When people ask John Frame what his work is about, he feels that the real answer should be that it isn't *about* anything. That is not to say that the work is meaningless, rather that it carries its meaning in its own way and on its own terms. He has said that his work expresses his interest in the age-old questions: Where did I come from? What am I to do while I am here? What, if anything, happens when I'm gone? To Frame, those questions are present in the work as the deepest form of content. He thinks, however, that the only way to understand that meaning is by looking and letting go of thinking.

KEVIN M. MURPHY AND JESSICA TODD SMITH

NOTE

1. From "The Unity of Art" lecture delivered in Manchester, March 14, 1859. Reproduced in *The Two Paths*, vol. 10 of *The Works of John Ruskin* (Kent: George Allen, 1878), 49.

THE HANDMADE
IMAGINATION
OF JOHN FRAME

by David Pagel

he photographs, figures, and film in *Three Fragments of a Lost Tale: Sculpture and Story by John Frame* spring from the imagination of an artist who has never hesitated to follow his dreams.

Nor has he shied away from the plodding, pedestrian difficulties of bringing those dreams to life without diminishing their magic, diluting their power, or destroying their mystery. Each viewer is encouraged to experience Frame's works as his or her own—with all of the fragile grandeur, fantastic vividness, and inexplicable intimacy uncovered by first-hand, up-close observation.

Today, we think of such ambitious, multi-talented over-achievers as multi-taskers—exceptionally efficient folks who are capable of doing three or four jobs at once, simultaneously performing the duties of a small staff or company. But the frantic activity and breakneck pace associated with contemporary multitasking are nowhere to be found in Frame's patiently handmade art, which calls to mind neither the distracted superficiality of the digital age nor the instantaneous gratification promised by modern telecommunications. Instead, Frame's meticulously sculpted figures, painstakingly made props, consummately tailored costumes, and elaborately fabricated sets, not to mention his sensitively lighted scenes, gorgeously scored story, beautifully composed photographs, and extraordinarily poignant frame-by-frame animation bespeak the multiplicitous, mix-and-match talents of a jack-of-all-trades.

The unspecialized expertise in which jacks-of-all-trades traffic has all but disappeared from our age of overspecialized expertise and niche-marketed nuance. Like repairmen, who have less and less work to do in a disposable society based on planned obsolescence,

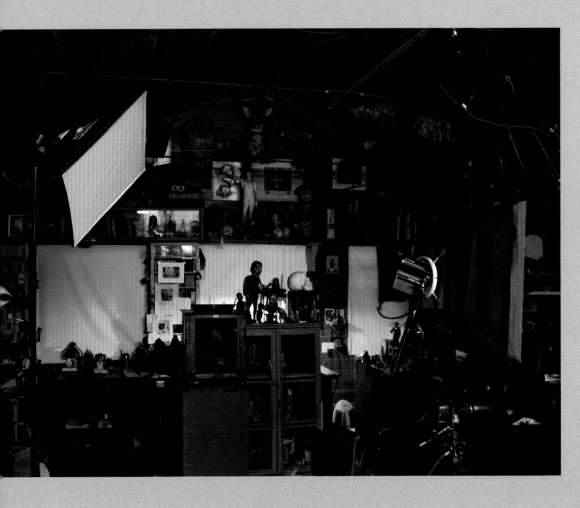

jacks-of-all-trades seem to be on the fast track for extinction, if they do not already belong to a bygone era. In either case, their outlooks and attitudes are anomalies in the digital phase of the information age: outdated, old fashioned, and seemingly irrelevant to its restless aggression, goal-oriented directness, and obsession with instantaneous immediacy. Jacks-of-all-trades and other multipurpose folks have not, however, disappeared altogether. Many, like Frame, have simply gone underground: out of the spotlight, beneath the radar, and away from the headlines. Their off-the-beaten-path existences demonstrate that there is more to life than getting the job done quickly and efficiently and with as little fuss as possible.

Away from the pragmatic calculations of everyday life and the cost-benefit analyses of economic endeavors, Frame's impressive repertoire of skills, which includes woodworking, film editing, and composing music, among many others, expands according to its own

serendipitous logic. Frame's work follows a meandering path that is not shortened or straight-jacketed by the demands of rationality or profitability, but instead is able to take off after the most far-fetched inklings of his unpredictable imagination. As if throwing everything that is stable, reassuring, and purposeful to the wind, Frame has made a space for himself—a one-of-a-kind arena—in which to pursue all-but-impossible leads, long-shot intuitions, and the merest hints of sense. It is the perfect environment for his art, which is all about passing on some of that same freedom to viewers, with all of its enigmatic openness, purposeful playfulness, and infinitely rich potential. Frame's works do not illustrate a single, definitive story—or, for that matter, illustrate anything at all—so much as they entice a viewer's imagination into the action. Each of us is free to interpret the expressions and gestures of the artist's characters howsoever we see fit, reading their body language variously and diversely, and wondering, whimsically and seriously, about the relationships between and among them, in different settings and scenarios. We speculate about what may have happened in their pasts and what might happen next, now that our lives have crossed paths with theirs, however briefly.

John Frame's art takes a big step—or two—back from the hurly burly of urban life in order to engage viewers more fully, meaningfully, and freely than if it stayed above ground, where it would be forced to shout, scream, and speak swiftly if it wanted to be heard above the everyday din. But being flashy and bombastic—to get noticed among the relentless onslaught of visual stimulation that makes up the image glut of modern life—would defeat the purpose of Frame's quietly contemplative art: to make space for rumination, reflection, and other slow-brewed experiences. When individual viewers engage Frame's art, we do not leave the world behind so much as we take a break from the status quo to perhaps come to understand our place in it more deeply. There is great freedom here. And it cannot be had by proxy. In the world Frame has created, meaning is a do-it-yourself enterprise that requires active, ongoing participation, as well as the risks and responsibilities that accompany all creative endeavors.

Pondering questions that just may be impossible to answer—but are impossible to ignore once they get in your head—is essential to Frame's art. Working with his hands and carefully crafting actual objects are essential to the kind of insights Frame is after. His goal is to come to

some kind of understanding of his life's meaning and purpose—that he did not know when he began—while at the same time inviting viewers to come to some kind of understanding of their own lives. Such big, existential questions are often burdened with so much portent and pretense that even addressing them comes off as grandiose and heavy-handed. To avoid such pitfalls, Frame sticks to humbly crafted wood, to unpretentious, toy-sized figures, and to scenarios so basic that a child could understand them. He does not, however, turn his back on modern technology. The Internet, with its nonstop search engines, has allowed him to expand the scope of his quest for the antique scientific

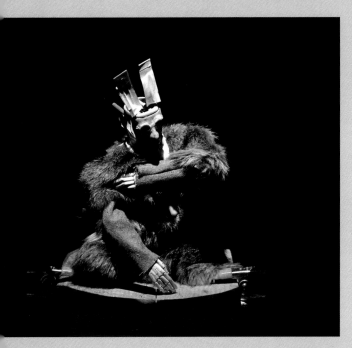

instruments and nineteenth-century bric-a-brac that he adapts and transforms in his art, creating customized, one-of-a-kind hybrids. Ten years ago, Frame was limited to the yard sales, flea markets, and junk stores he could physically visit. Today, there is virtually no limit to the specialty shops at his fingertips. The same is true of the film and music software Frame has taught himself to use when creating his stop-motion vignettes and digital photographs. Although the mechanics of stop-motion animation have not changed since the late nineteenth century—take a picture, move the figure 1 to 3 millimeters, take another picture, over and over and over again, 24 times to make 1 second of film—digital technology has advanced so far and become so accessible that it is now possible for one artist, working alone in his studio, to make films as visually sophisticated as big-budget Hollywood productions and to record music at the same state-of-the-art level. In other words, it's a great time to be a jack-of-all-trades.

Frame takes advantage of technology but does not embrace it for its own sake. He employs the latest software and hardware to intensify the emotional impact of his art, which ranges from endearing sweetness to heart-wrenching sorrow, from relaxed contentment to agitated need, and from the clarity of wisdom to the puzzling befuddlement

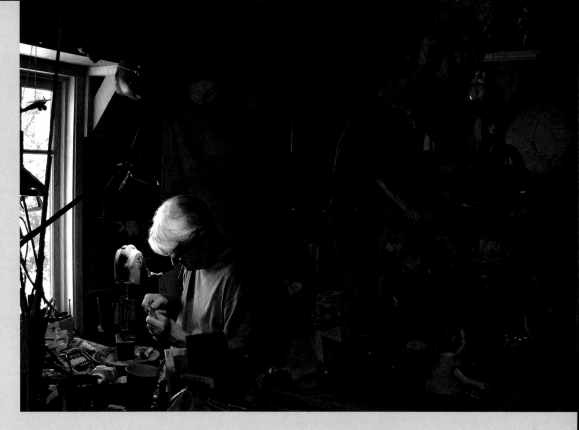

of confusion. Frame's empathetic figures stand in for a wide range of human feelings, desires, and aspirations. They draw profound sentiments out of anyone lucky enough to come across them in the right mood, which involves being comfortable with uncertainty and being willing to figure things out for oneself. Frame's figures throw open the doors of a world unlike any that has ever existed, yet is strangely familiar. In it, our sensibilities, memories, and intellects get caught up in a focused yet open-ended whirlwind that drives us into a deeper understanding of our connections to those around us, to the past and the future, as well as to the cosmos—and to what lies beyond our comprehension. This is the mystery at the heart of Frame's art, where there is plenty of room for all of us, and just about anything one might imagine.

About thirty years ago, Frame knew he was an artist. But he had no idea if he would find the right material with which to work. Everything he experimented with—painting, printmaking, drawing—was not fully satisfying until, one day, when he picked up a piece of wood and began to carve it. He was hooked. In a split-second, he knew, in no uncertain terms, that he had found his expressive medium, the material that would captivate and fascinate him as if he had been born

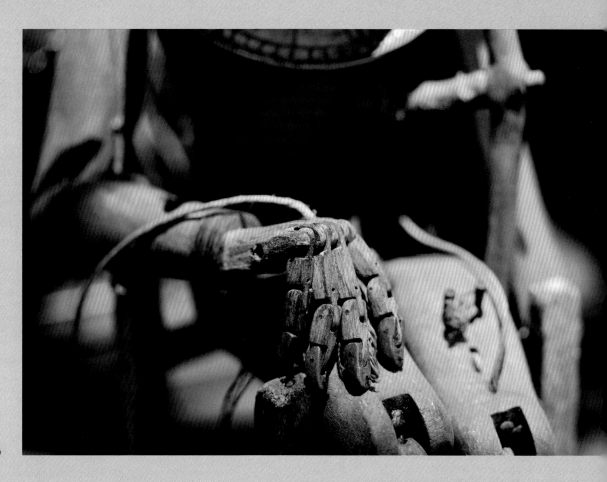

for it. For the next twenty-five years, the challenges of wood, and his capacity to work wonders with it, resulted in intimately scaled figures, scenes, and body fragments that suggested odd dramas—sometimes comic, sometimes tragic, sometimes both. Frame found them to be deeply satisfying, and continued making them as a way of exploring his self, the world, and whatever he was able to find out about them.

Then, not quite as suddenly, but just as dramatically, Frame's interest in carving and assembling fanciful, pint-size figures diminished. His heart and his head were no longer into what his hands were doing. He stopped learning from his work. His fascination vanished. The magic was gone. And, being utterly uninterested in cranking out formulaic pieces, he stopped making sculpture and contemplated abandoning art altogether, perhaps going into cabinet-making or some other sort of utilitarian craftsmanship.

Not long after that, guest curator Gordon L. Fuglie at the Long Beach Museum of Art organized *Enigma Variations: The Sculpture of*

John Frame, 1980–2005. This survey exhibition, and the enthusiastic responses of many visitors, rekindled Frame's interest in carving and assembling small figurative sculptures. But his interest was short-lived. He made only one figure, a crippled boy with a tiny tree branch growing out of his nose. And that was it.

This was the case until four years ago, when Frame awoke in the middle of the night, awakened by what seemed to be a physical nudge or jolt. As soon as he was conscious, he had a waking dream that felt like a massive download from a source he still does not fully understand. What was clear to him was that he knew what he would spend the rest of his life doing: using the vision he had just had as the source for his next body of work, a cast of characters in elaborately detailed settings from a haunting story that he witnessed from start to finish. In terms of clarity and conviction, this epiphany was a lot like the one he had had at the beginning of his artistic career, when he discovered that wood was his medium. This time around, what he learned was that sculpting singular figures and setting them in fixed positions, with frozen expressions and suspended movements, was not enough. His new body of work had to be even more expressive than before: each piece had to seem to him as if it had taken on a life of its own and was, in a sense, no longer under his control. His job as an artist was to convey this sense of animated self-possession to viewers, as clearly and vividly as possible. It soon became evident to Frame that the best way to capture the reality of his vision was to make even more meticulously detailed figures, with more elaborate physical features, such as moving limbs, wrists, and fingers, as well as jaws, tongues, and eyes, so that each little creature could convey a great range of expressions. He could then photograph his figures in various postures, groupings, and settings, in different costumes, situations, and light. It also dawned on Frame that each of his multipurpose sculptures could be used to make stop-motion animated vignettes—or even feature-length films—that truly made it seem as if his idiosyncratic cast of characters had come alive. The possibilities were endless.

To ensure that he didn't miss anything, Frame sat up in bed, turned on the light, picked up a notebook, and began recording the details of the story. It is a tale of loss and discovery, yearning and compromise, hope and wisdom. It begins with two characters. The first, Mr. R, is an older man with gentle eyes and rabbit-like ears, who dozes contentedly

in a garden, having fallen asleep reading a book. The second, Cat V, is a younger man with feline features and a large backpack. He awakens Mr. R and entices him to embark on a quest. It quickly becomes obvious that they are living in the aftermath of a catastrophe and that many of their civilization's achievements are no longer possible, primarily because so much knowledge has been lost. The notion to go on the quest comes from O-Man, an inquisitive astronomer who has taken up residence in the workshop where their civilization's highest art form was once made: a type of glowing, rainbow-tinted glass that seemed to breathe and possessed the power to transform the souls of those who gazed upon it. The only person who knew how to create the glass is gone. O-Man struggles earnestly to recover the necessary knowledge but cannot succeed. He believes that a crippled boy, who was always around the workshop, sweeping up and running errands, may know the secrets needed to manufacture the glass. So Mr. R and Cat V set out to find him.

On their journey, they travel through a landscape that appears to be both Italianate and Japanese, generally medieval but also somewhat futuristic. They cross paths with various characters, human and animal hybrids, some with mechanical limbs. They visit curious towns, each with its own style and culture. In the course of their journey, they talk of the old days, when they led a traveling theatrical troupe of twelve gnome-like characters, known as the Tottentanzers. Since then, the Tottentanzers have been on their own, performing their morality plays and theatrical dramas with the same entertaining energy as before. But, without their two leaders, they no longer understand what they are doing. Neither uninspired nor farcical, their performances are nothing like the first time around.

Eventually, the duo and their entourage find the crippled boy. To him they explain their desire to master the process of glass making and to recapture the lost magic of the art form. The boy listens carefully, reveals that he probably knows enough to help them, but ultimately declines, preferring to carry on with his humble life in the wilderness. Mr. R accepts this decision with equanimity, understanding that the boy's new life is fulfilling and not worth abandoning for the hope of recapturing the past. When Mr. R and Cat V return from their journey and inform O-Man of its outcome, he is uncomprehending and heartbroken.

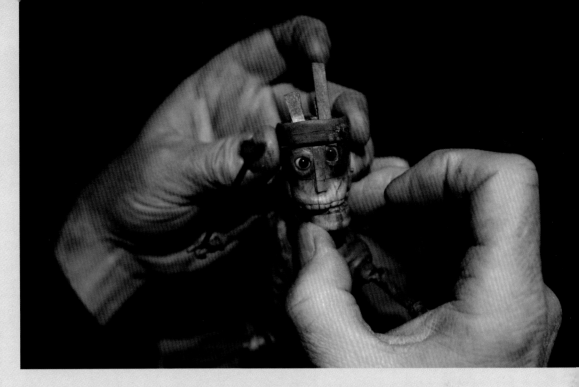

This narrative can be understood as a parable or a metaphor for Frame's approach to art-making: searching for something that's not understood and perhaps finding it in unexpected places; getting what you need indirectly, not through will or conscious decisions, but by other, more oblique, serendipitous, out-of-the-way means. In the story, what the glass was designed to deliver—self-knowledge—comes to Mr. R by way of his experience of his journey and what he learns at its conclusion. O-Man has a fundamentally different experience and comes to a profoundly different understanding of its end: sadness and frustration at failing to attain what he was after, the capacity to make the fantastic, transformative glass. Mr. R values intangible, unpredictable experiences and gets what he needs. O-Man does not attain the singular thing he desires: the lost technique whose mastery would have made yesterday's art possible once again.

Contemporary viewers of Frame's art find themselves in a position very similar to that of these characters: awed, even daunted, by the strange, densely detailed world before us—which is nothing like the everyday reality we have left behind—and confused or confounded by what we are meant to make of its unfamiliar settings, eccentric accouterments, and idiosyncratic characters. If, like O-Man, we search for the single thing we think we need to know—the ultimate meaning or clear

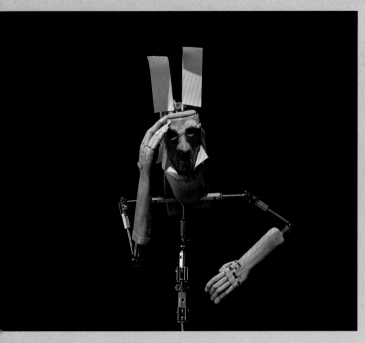 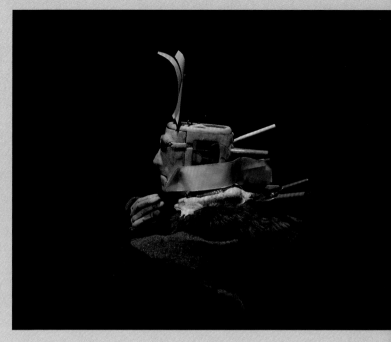

MR. R UNDER CONSTRUCTION MR. R IN FORMAL ATTIRE

lesson of the works before us—we will end up being frustrated by our failure to learn their secrets. Frame's art is too complex, multilayered, open-ended, and ambiguous to deliver such simple resolutions or tidy, easily summarized messages. But if we proceed less directly, with more patience and maturity than assertive or acquisitive neediness, we might just end up with an experience very much like that of the awakened reader, Mr. R. His insight into the nature of his life gives him serenity and allows him to make peace with his world, even though it is not the world that had, in the past, provided him with a sense of identity.

To help viewers get away from the idea that his characters are intended to illustrate a single, specific narrative, Frame has crowded together a couple dozen of his figures on a stage from his studio. Imagine a theatrical troupe of miniature players, waiting just off-stage, in the dark, with props and costumes. This conveys the sense of readiness and willingness embodied by Frame's engaging figures. Unlike his earlier sculptures, which dramatized single moments of implied stories by remaining in the same, unchanging position for our sustained, careful attention, his large group of new figures is presented more casually, as each might be in the artist's studio, awaiting activation by his hands. This setup is more like a storage shelf in a workshop than a staged

drama in a theater, a carefully shot and edited film, or a finished work of art in a gallery. Instead of focused resolution, we get all-at-once simultaneity—a sense of raw possibility, great anticipation, and seemingly infinite potential, awaiting only one thing: our imaginations to leap into action.

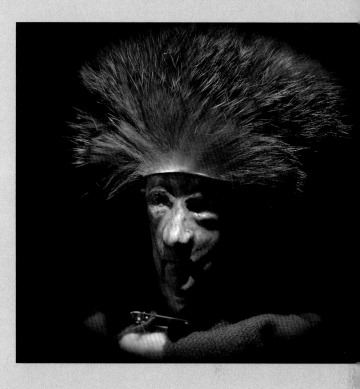

Frame's photographs and animated vignettes build on the potential embodied by his painstakingly crafted characters. His large-format photographs, in color and black-and-white, allow for changes in costume and setting, as well as in body language, gesture, and facial expression, all of which are enhanced and transformed by lighting, framing, and focus. What happens in Frame's photographs is similar to what transpires in the mind's eye of a captivated viewer: the characters come to life in ways that take them out of the story in which they originated and into intimate, participatory worlds neither foreseen nor controlled by the artist, not to mention by each viewer who falls under their spell.

Frame's stop-motion vignettes bring his characters to life even more fully. These flickering, handmade films invite viewers into snippets of stories with many points of entrance and even more points of departure. They do so by allowing Frame's cast of characters to be more like real people: to experience all sorts of situations, in which all sorts of challenges and conflicts arise. This approach causes the characters to interact and develop in ways no one expected. And it echoes John Frame's nighttime epiphany, when he became not a puppeteer with the power and inclination to control and micro-manage his art, but a silent witness, an attentive observer, and a faithful chronicler of the mysterious magic that unfolded before him. In this sense, the artist is essentially no different from any of us, who also are rewarded when we go underground, away from the superficiality of the contemporary world and into the quietly contemplative and curiously adventuresome world of the compassionate imagination.

MR. R IN TREE
VIEWING CAP

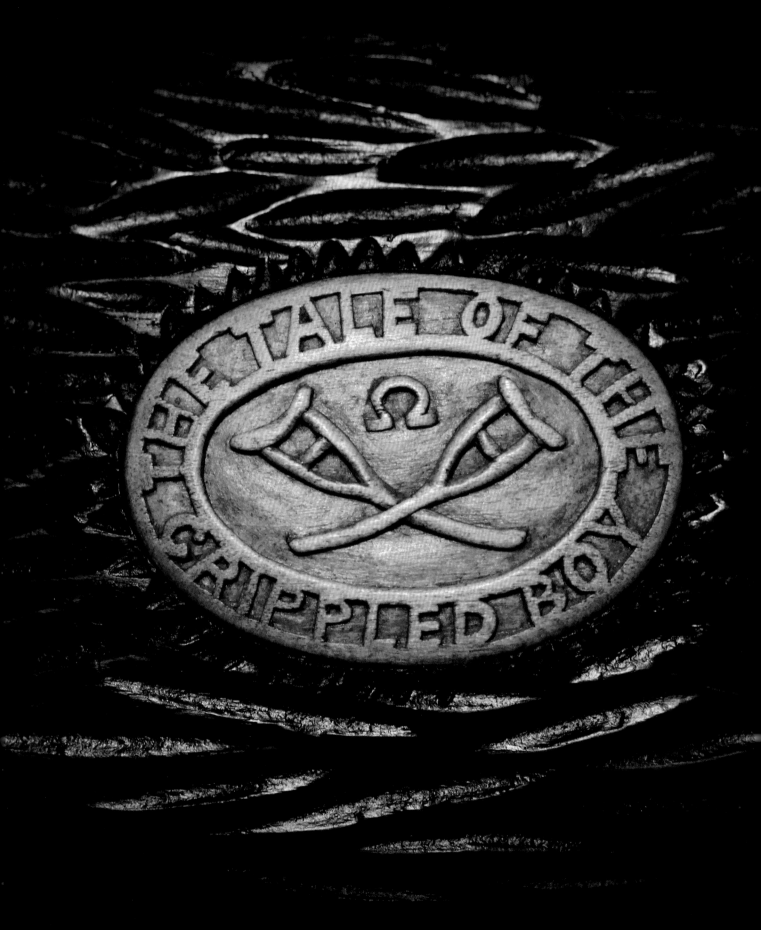

THE TALE OF THE CRIPPLED BOY

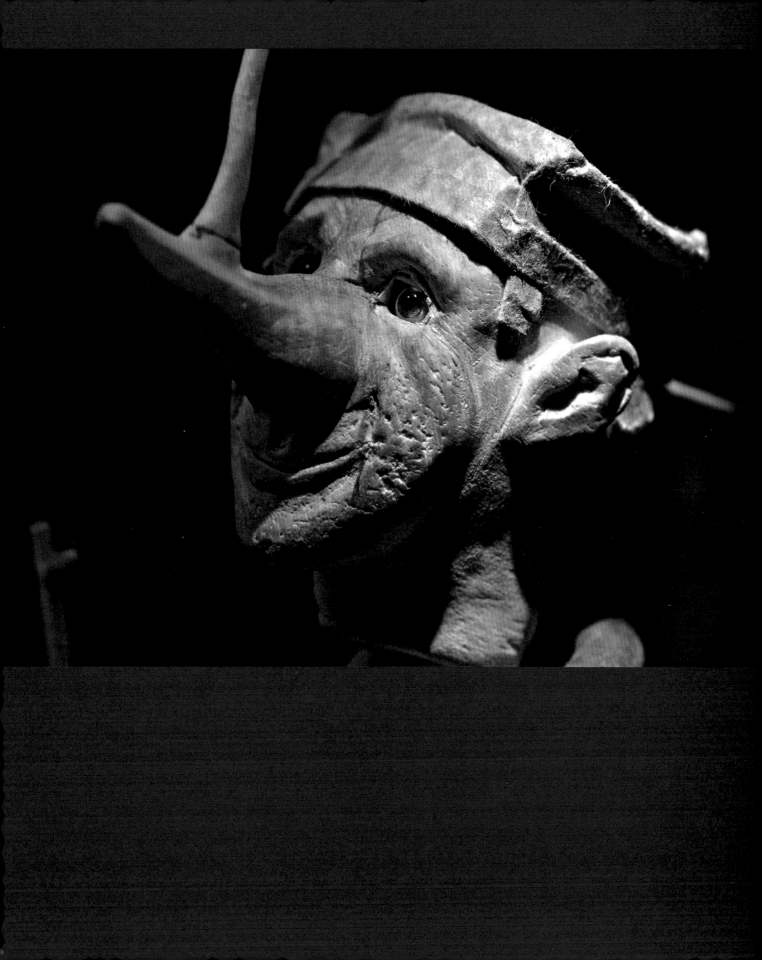

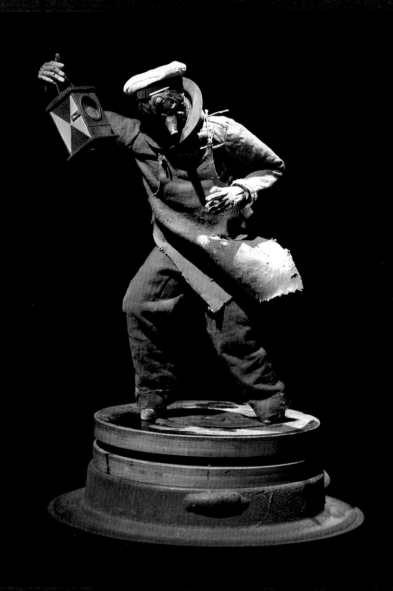

PERE JULES AGAINST THE WIND

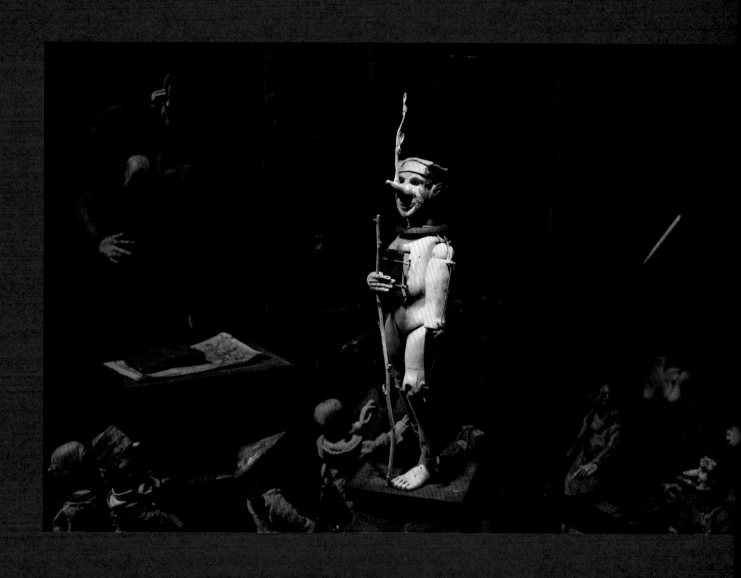

THE CRIPPLED BOY: MIDDLE PERIOD,
AMONG THE TOTTENTANZERS

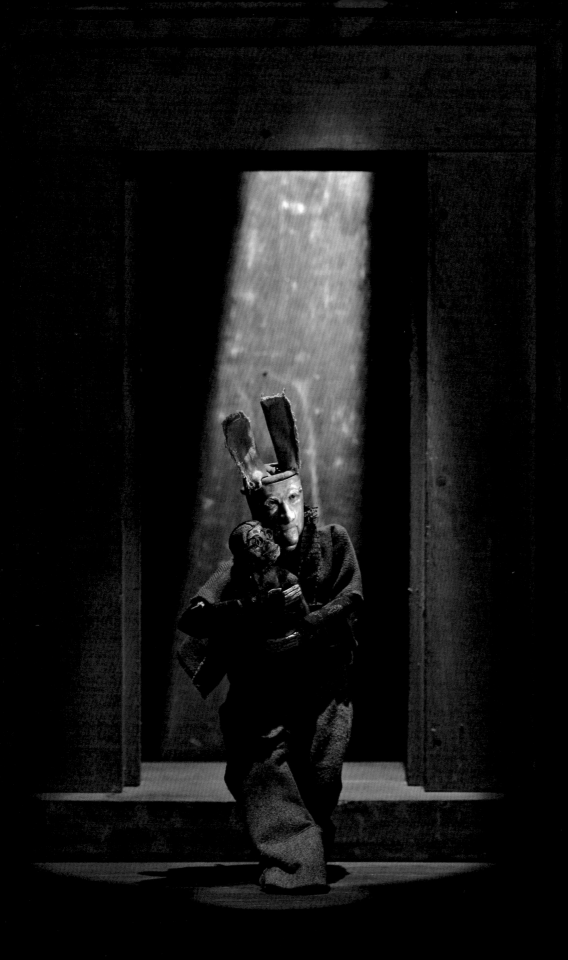

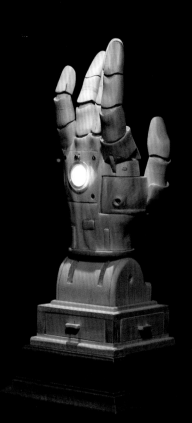
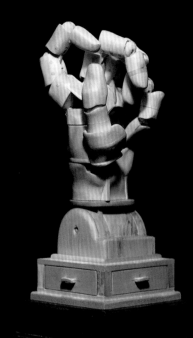
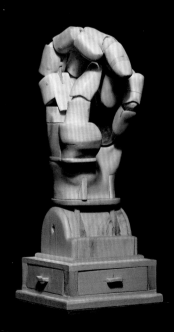
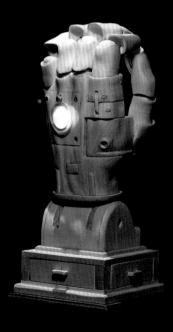

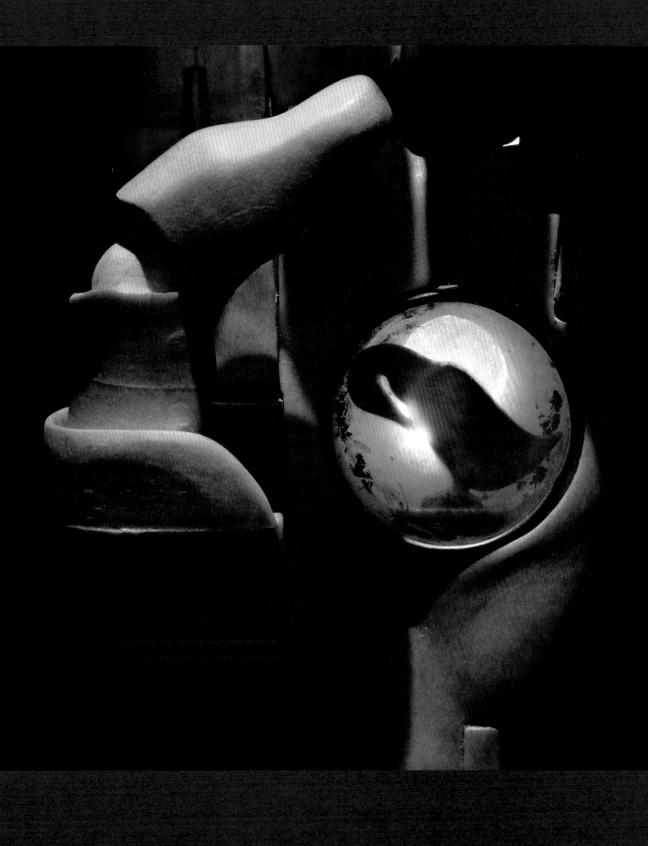

GLEYOT'S MATE TRANSLATING

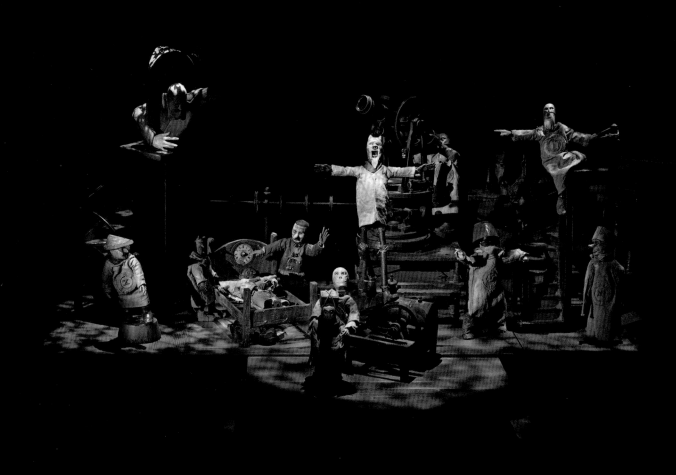

THE TOTTENTANZERS PERFORMING THE PLAY "PALACE OF SLEEP"

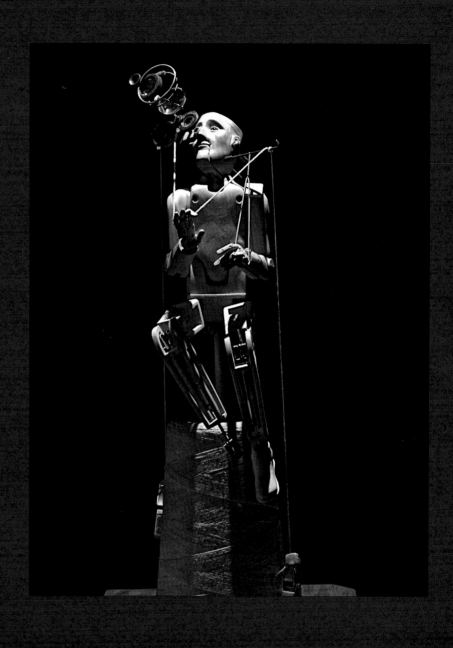

O—MAN PULLING AND PULLED BY STRINGS

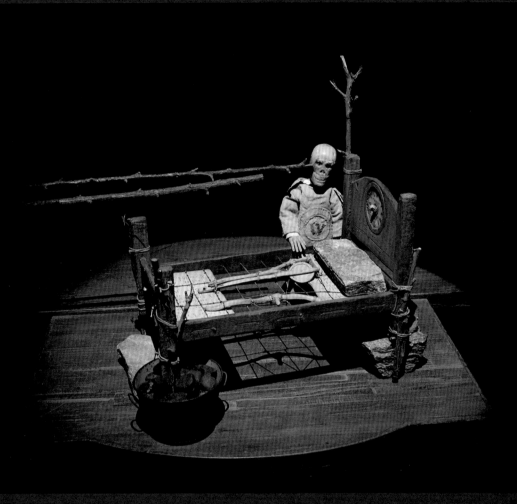

PIP AND THE BED (ANIMATION STILL)

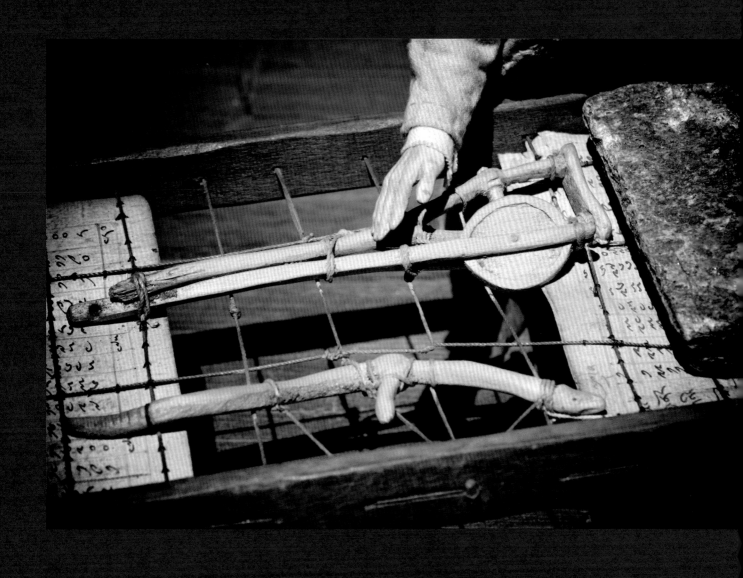

PIP AND THE BED (ANIMATION STILL)

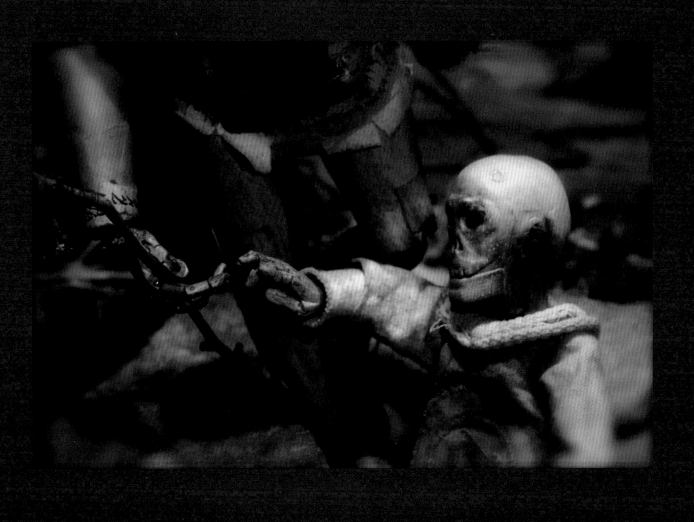

PIP AND THE BOY IN THE WILDERNESS ASHBUTTON WITH HIS NAMEPLATE

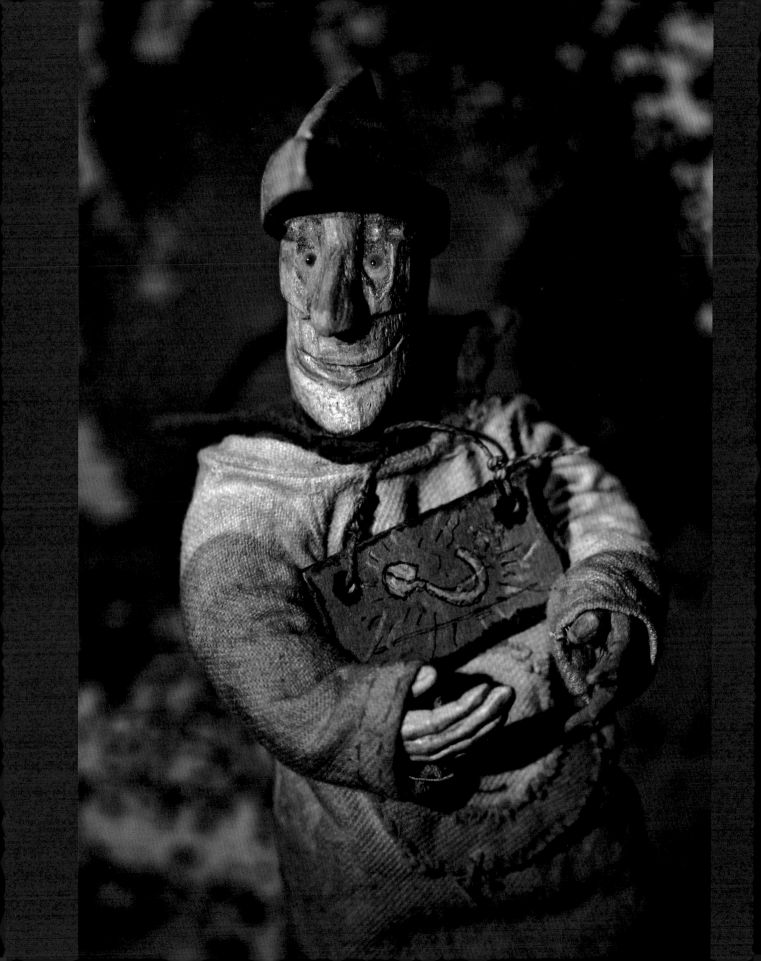

BUCKET AND FR. ANPHEME ICE SKATING

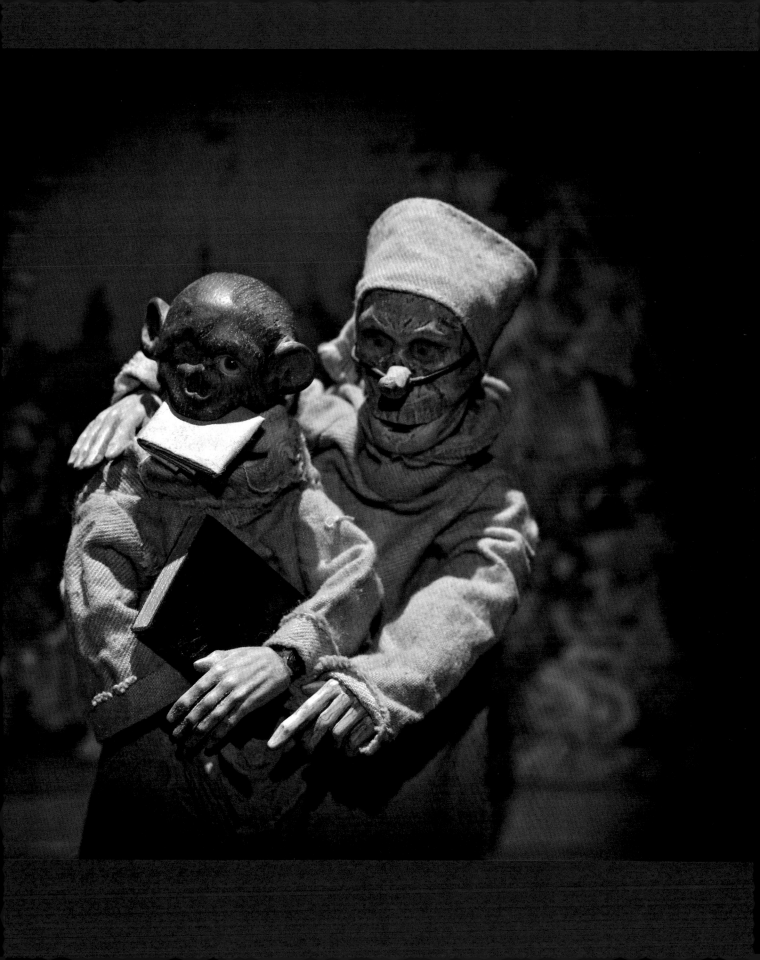

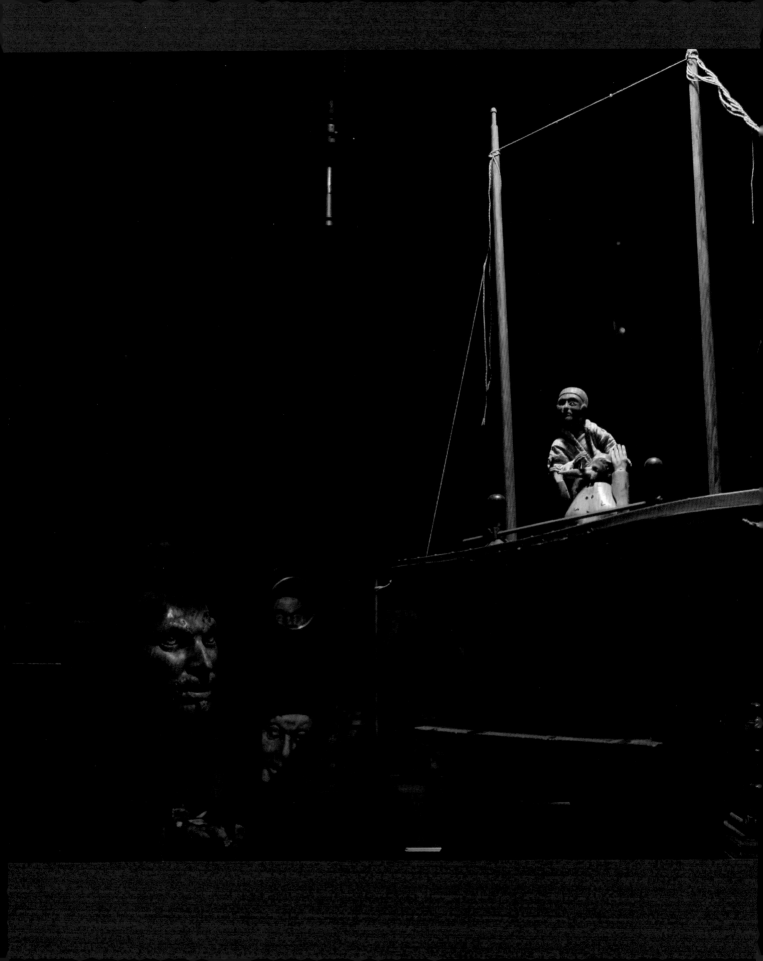

MESSENGER AND CHARGE AMONG THE WATCHERS

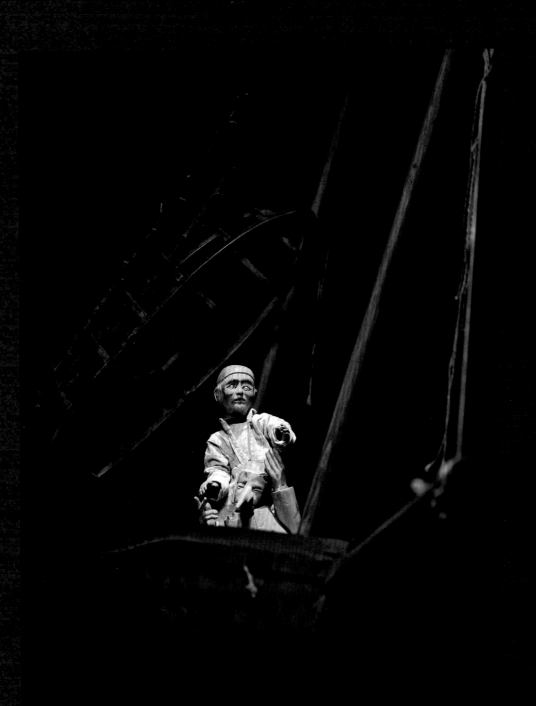

MESSENGER AND CHARGE RETURN WITH THE TEXT MESSENGER AND CHARGE

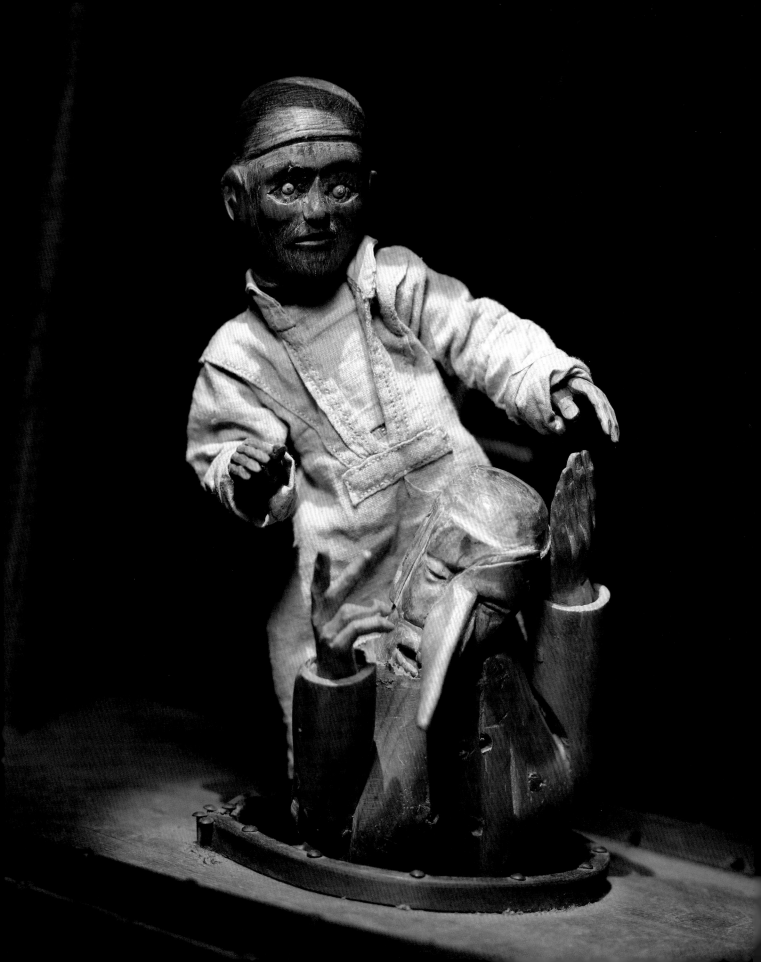

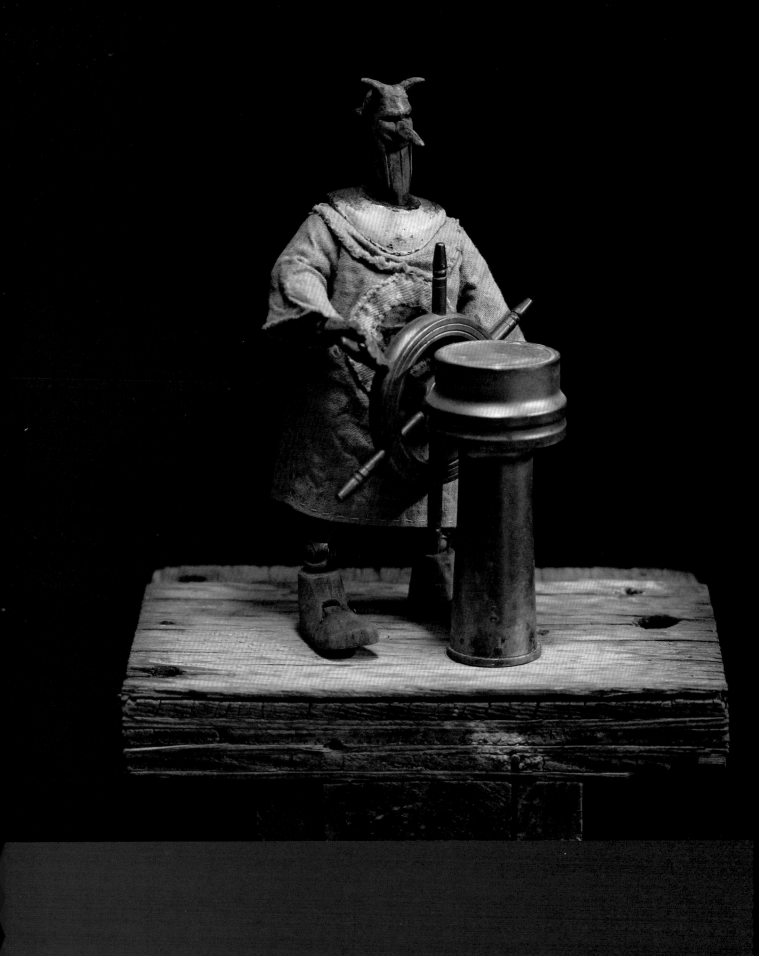

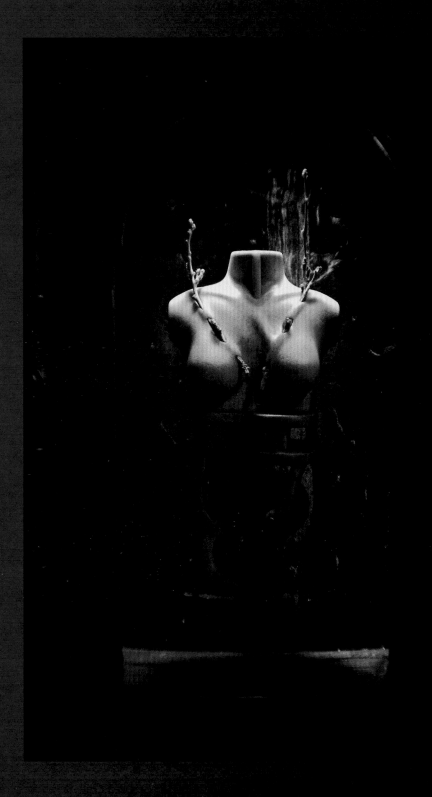

MILAGRO TORSO FROM
THE STREET OF PRAYERS

MILAGRO TORSO FROM
THE STREET OF PRAYERS

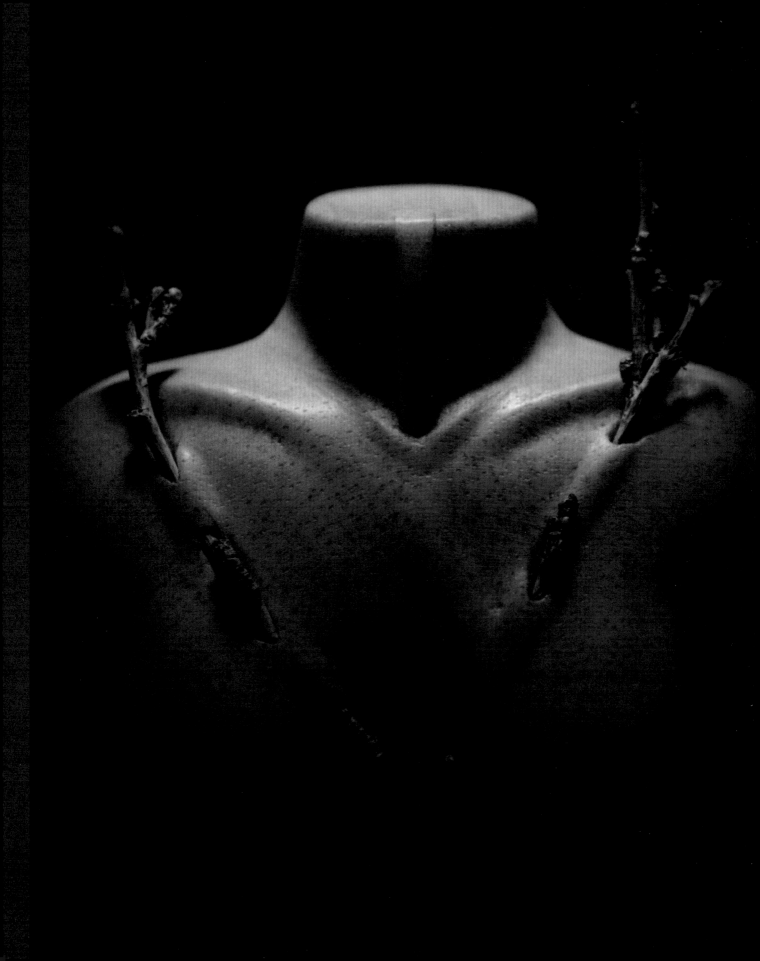

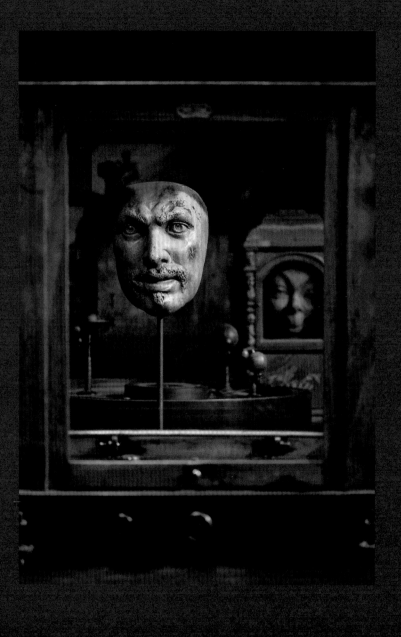

TWO OF THE WITNESSES LOOKING
THROUGH THE GLASS DOOR

THE FACE OF THE MESSENGER

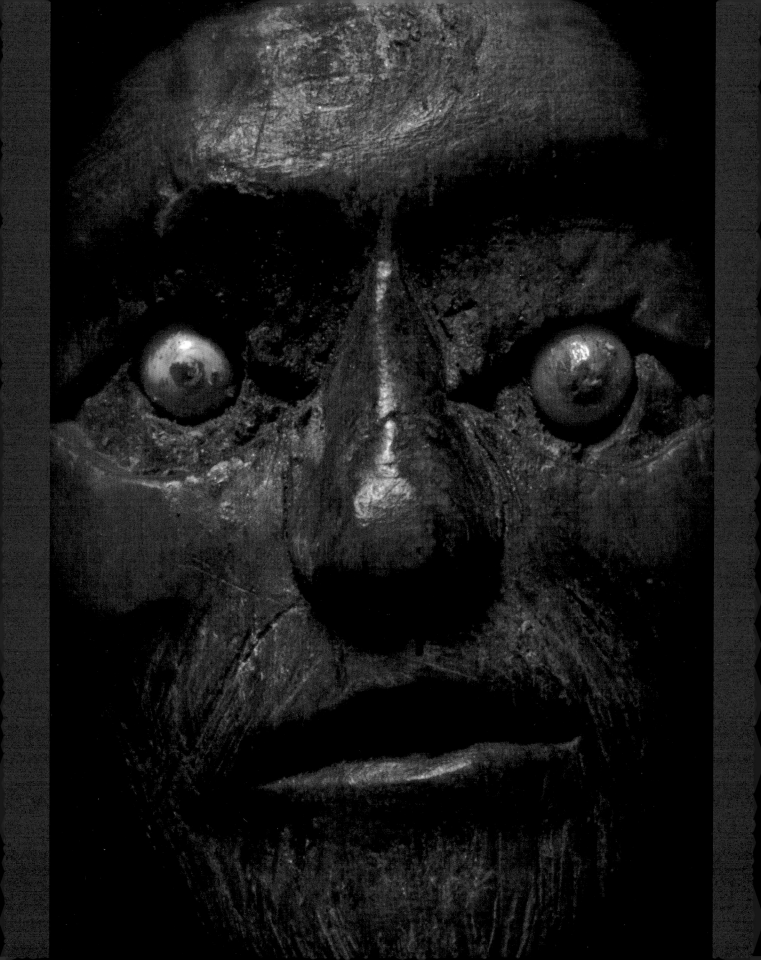

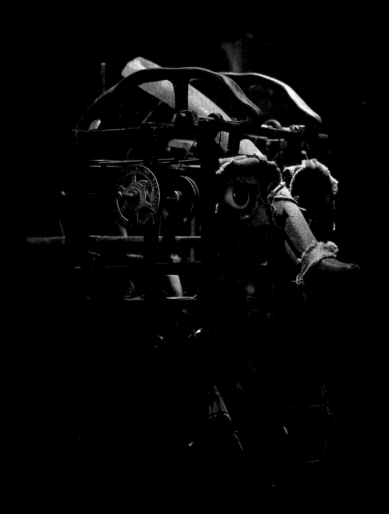

THE MECHANICAL HEAD REASONING

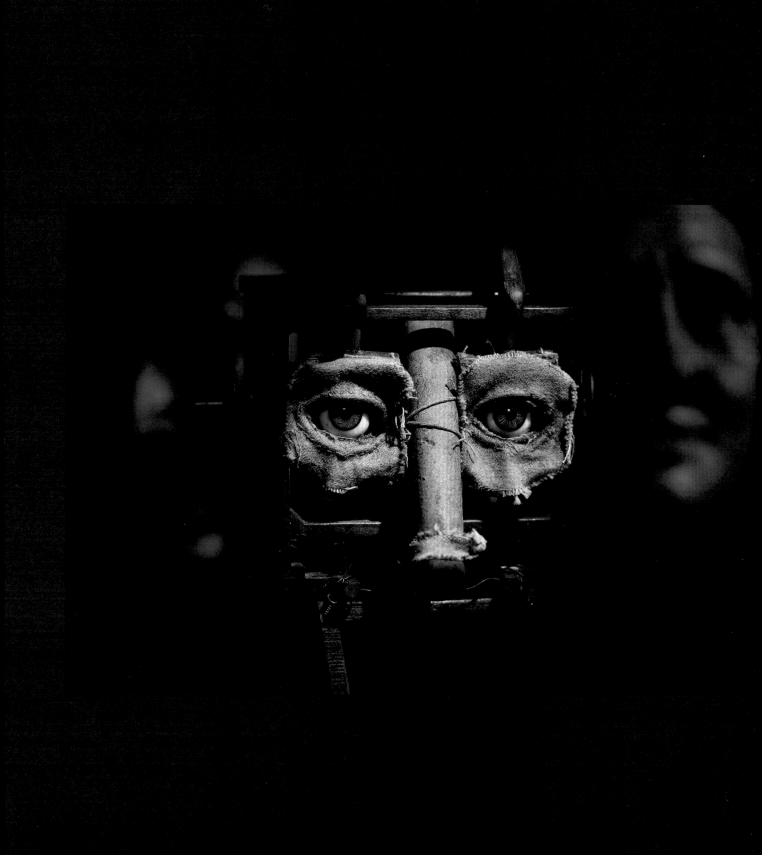

THE MECHANICAL HEAD CONCENTRATES ON US

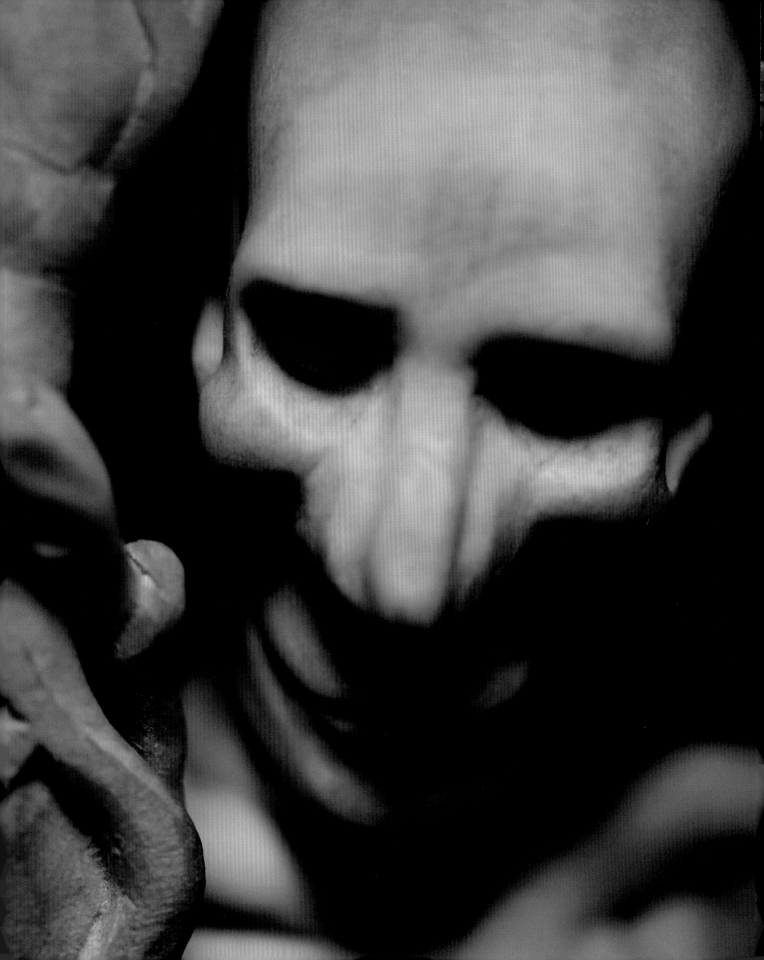

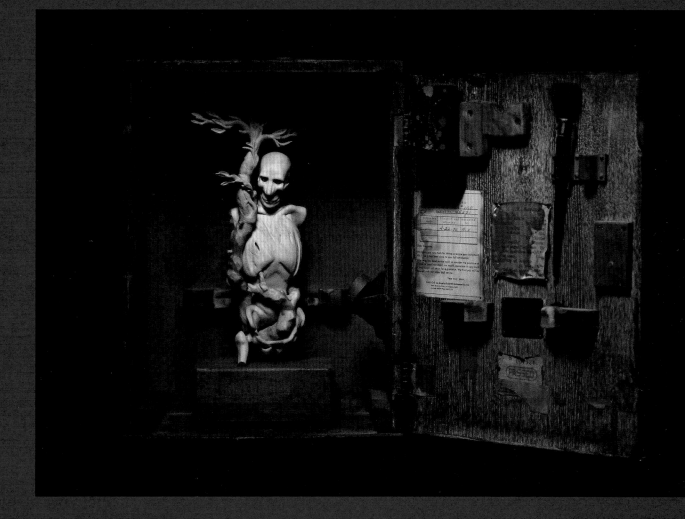

TRANSIT MILAGRO FROM
THE STREET OF PRAYERS

TRANSIT MILAGRO FROM
THE STREET OF PRAYERS

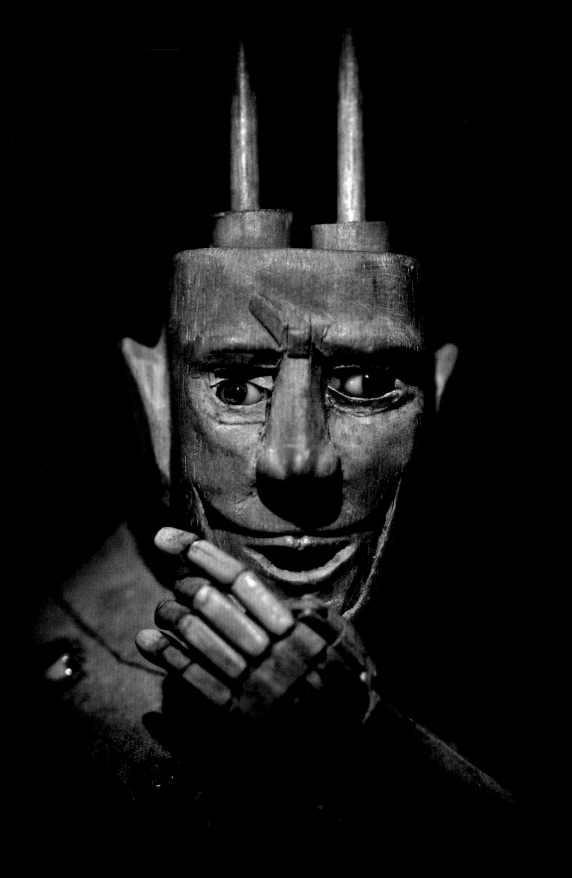

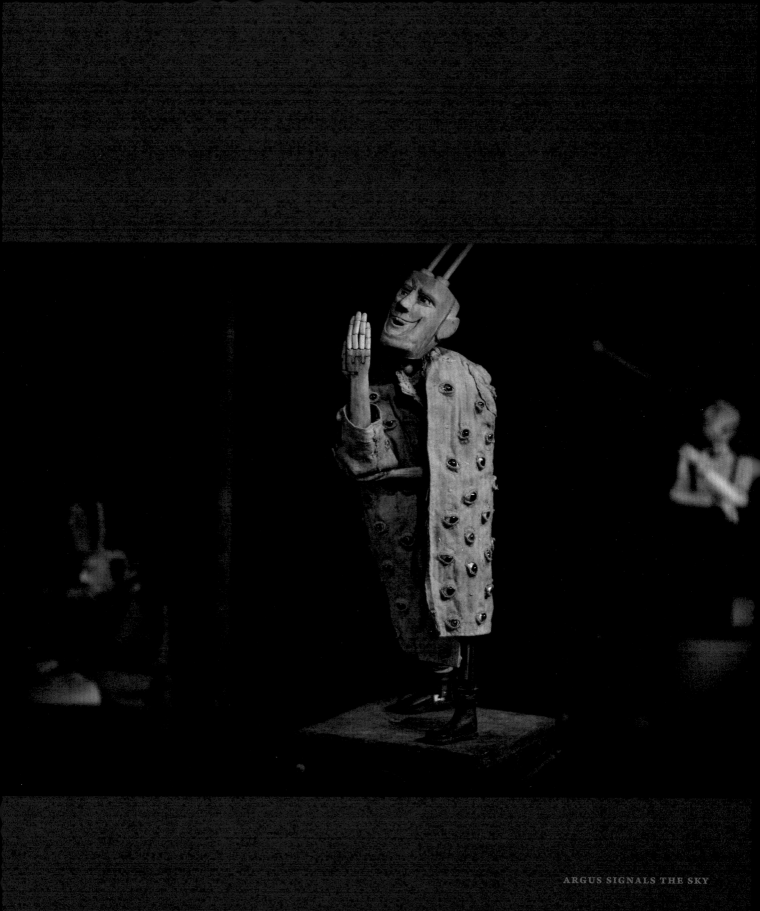

ARGUS SIGNALS THE SKY

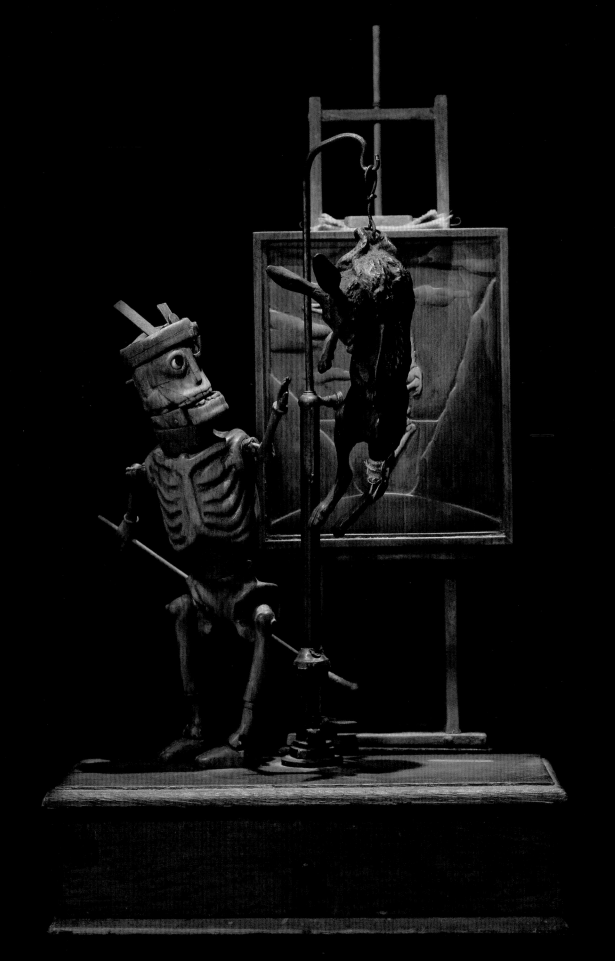

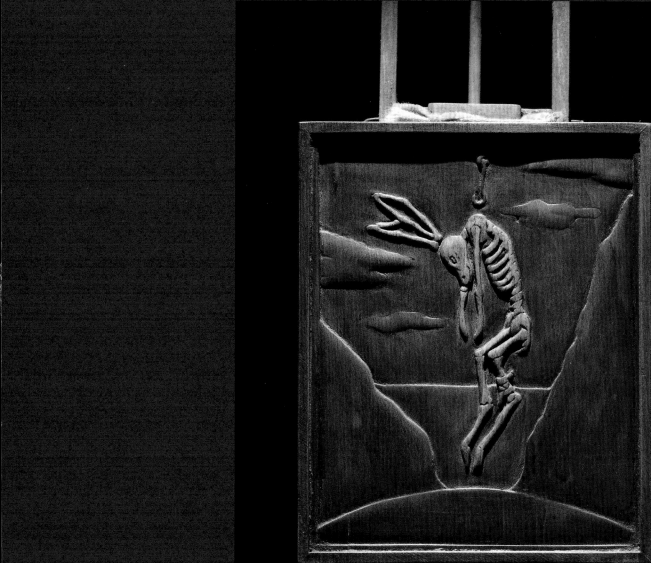

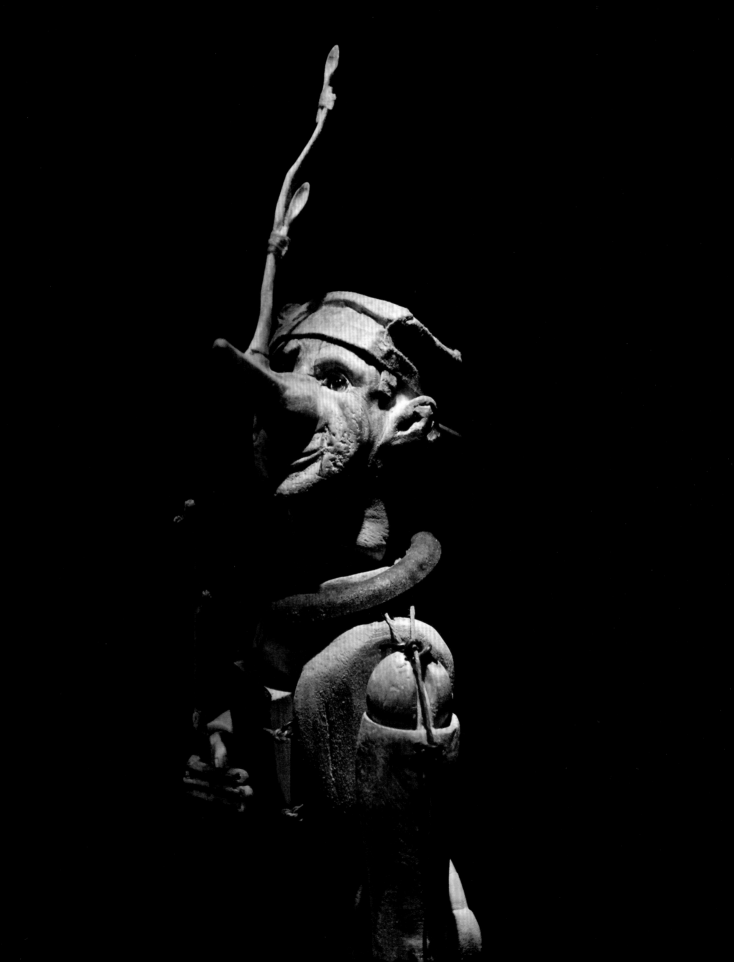

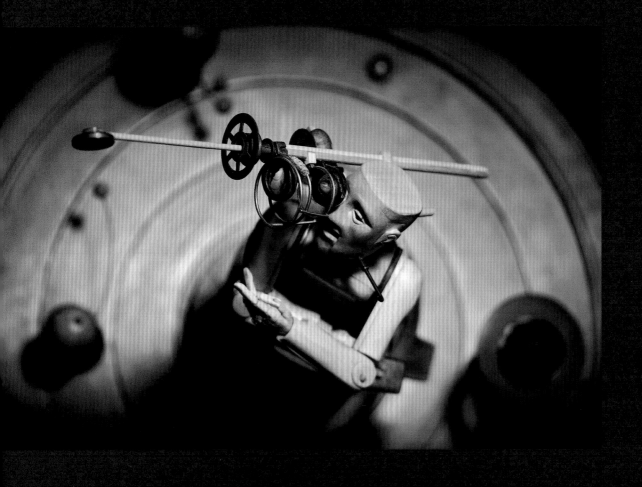

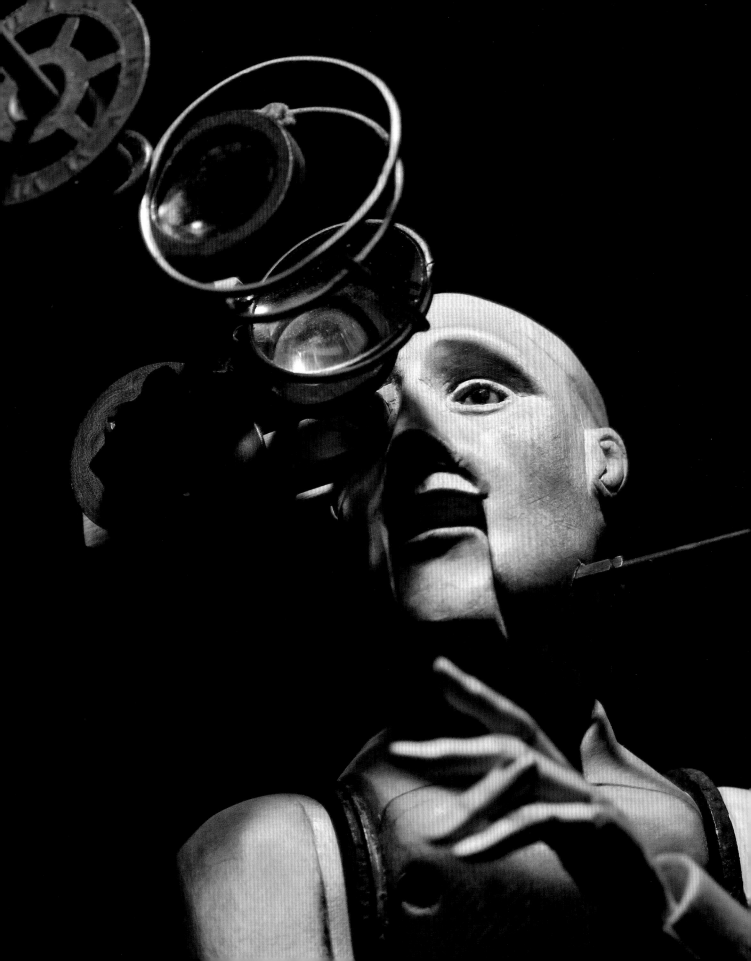

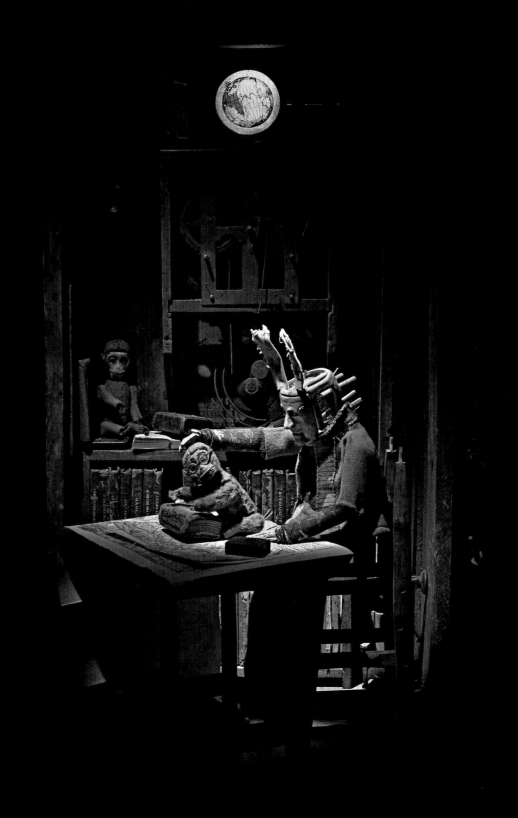

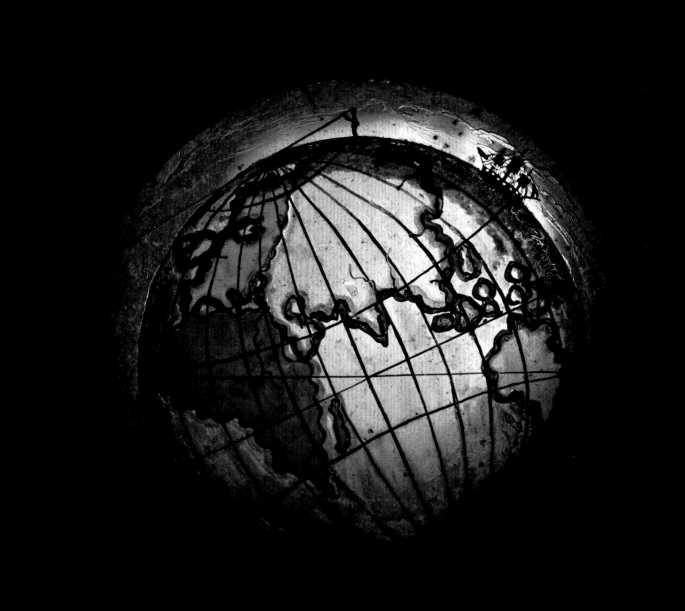

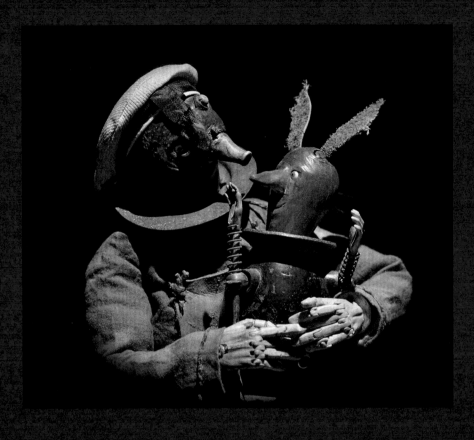

PERE JULES HOLDING POM

PERE JULES AMONG THE MACHINES
OF THE GREAT ATELIER

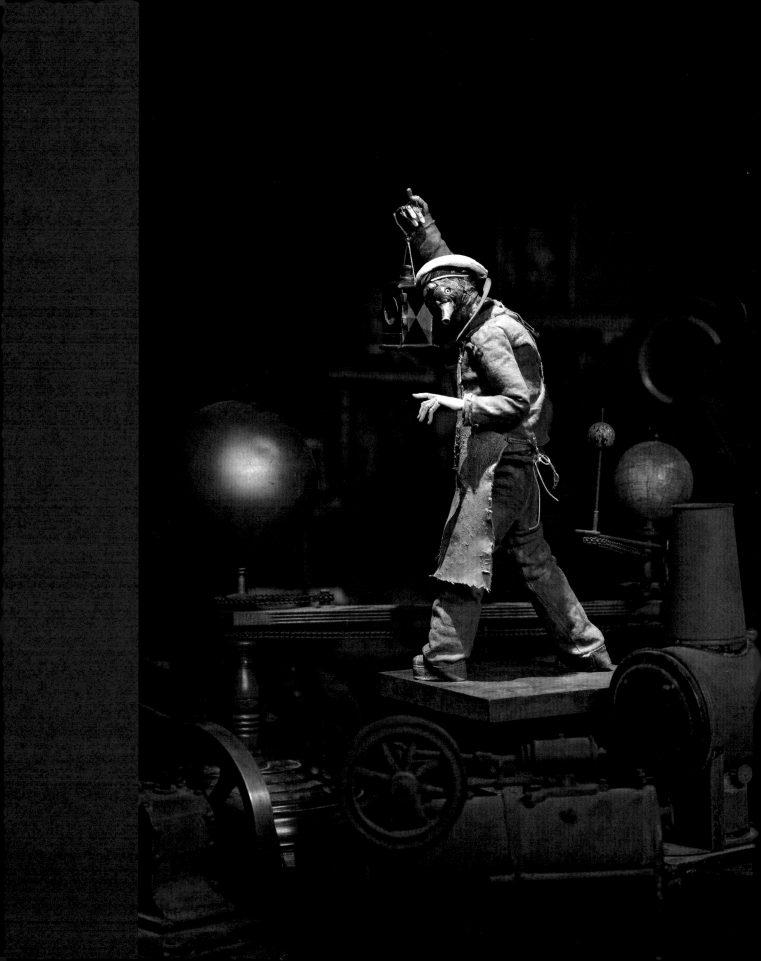

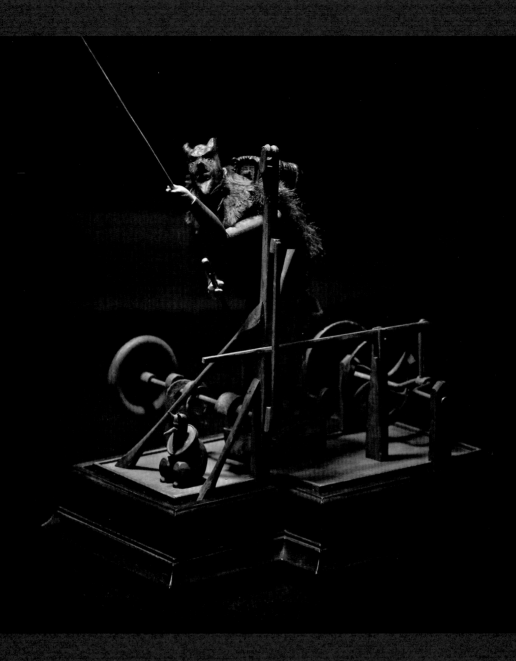

SCRATCH KEEPING GOD AT A DISTANCE

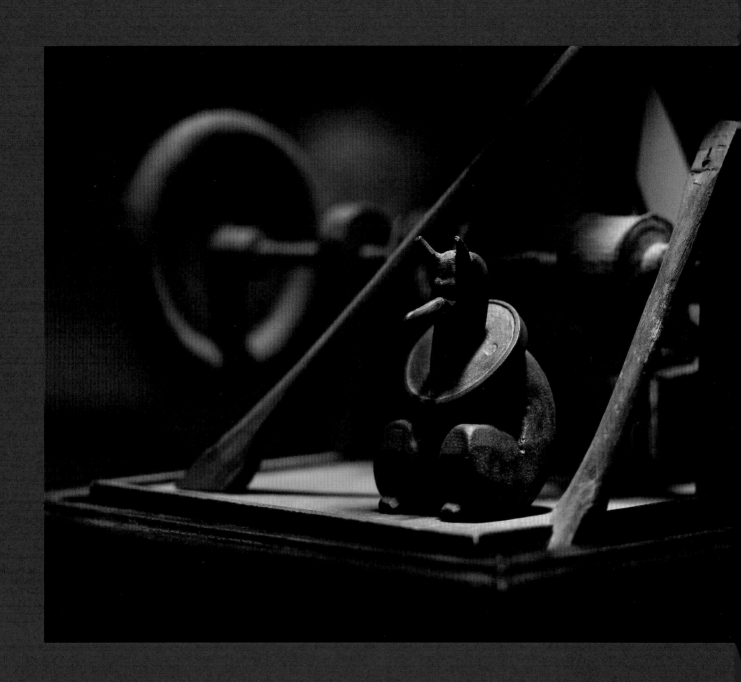

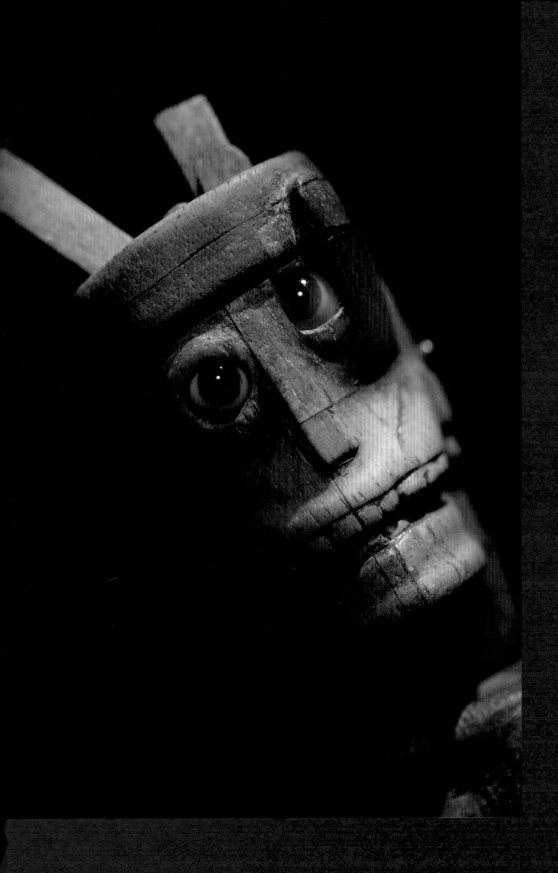

D'ARTAND LOOKING AT THE HARE

D'ARTAND CONFRONTS THE TOTTENTANZERS
BEFORE THE GATE OF DESIRE

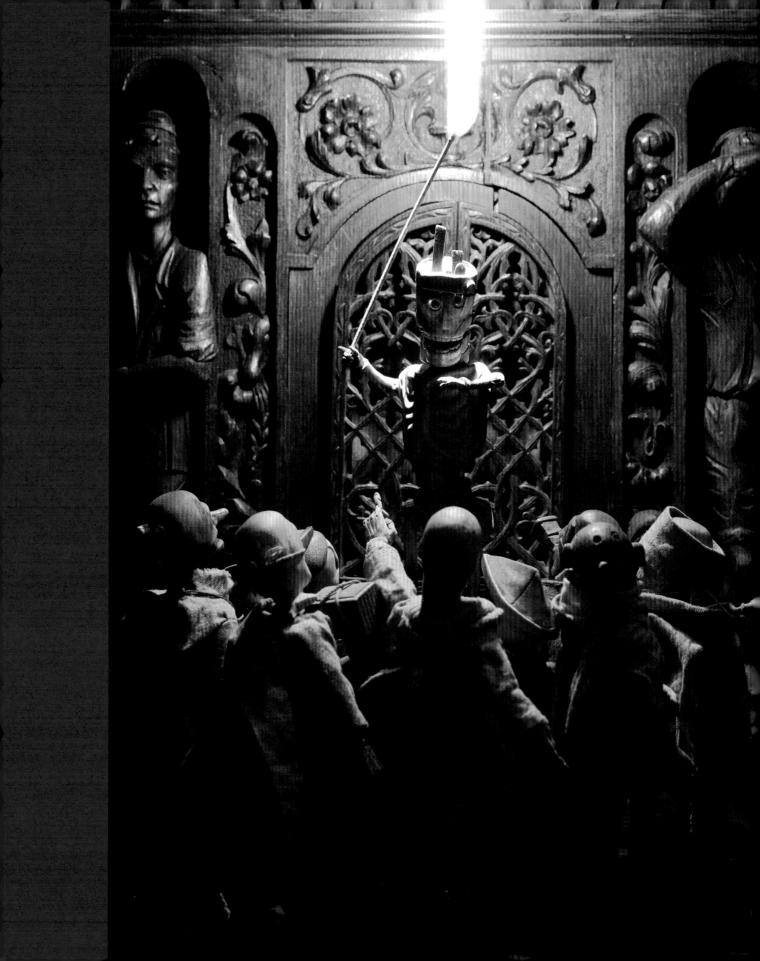

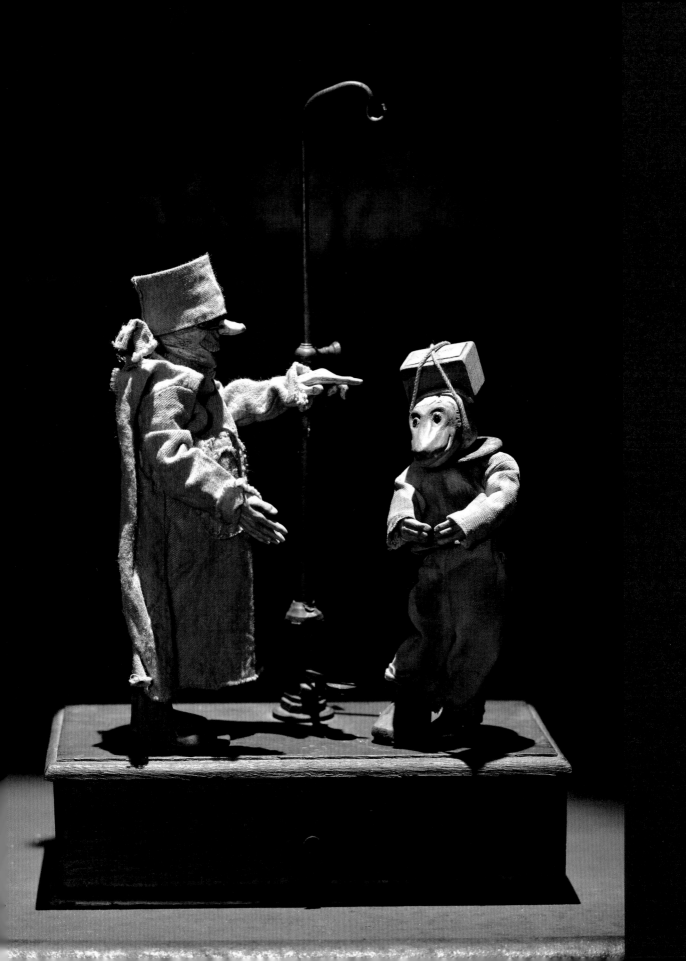

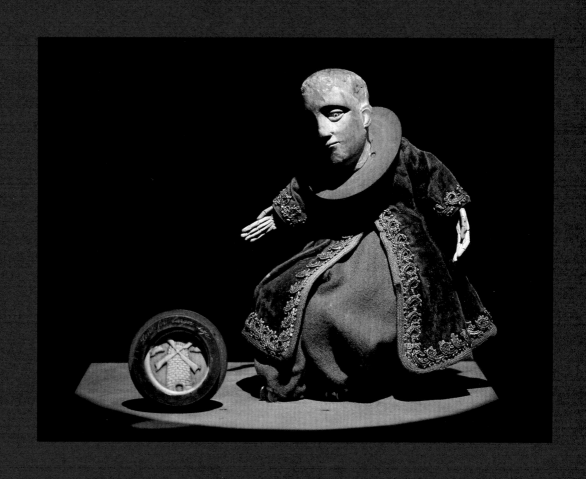

OSEP NAZ FINDS THE
WINDMILL RELIQUERY

HAND OF THE MAKER

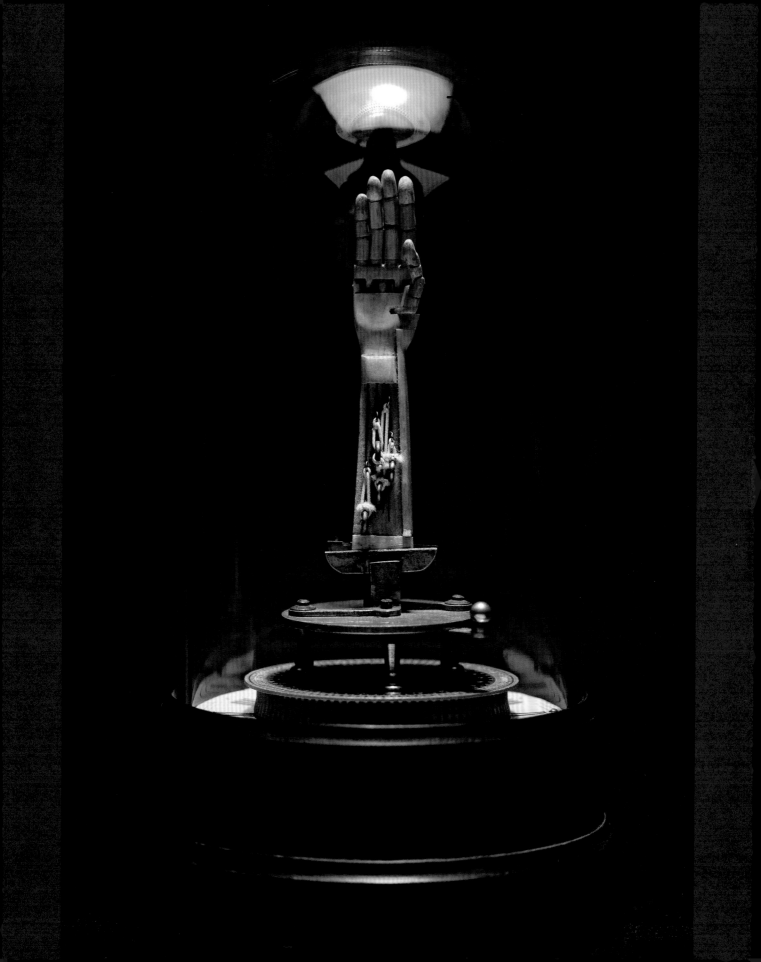

MR. R AND MONK TELL THE TALE TO THE
TOTTENTANZERS IN POOR TOM'S LIBRARY

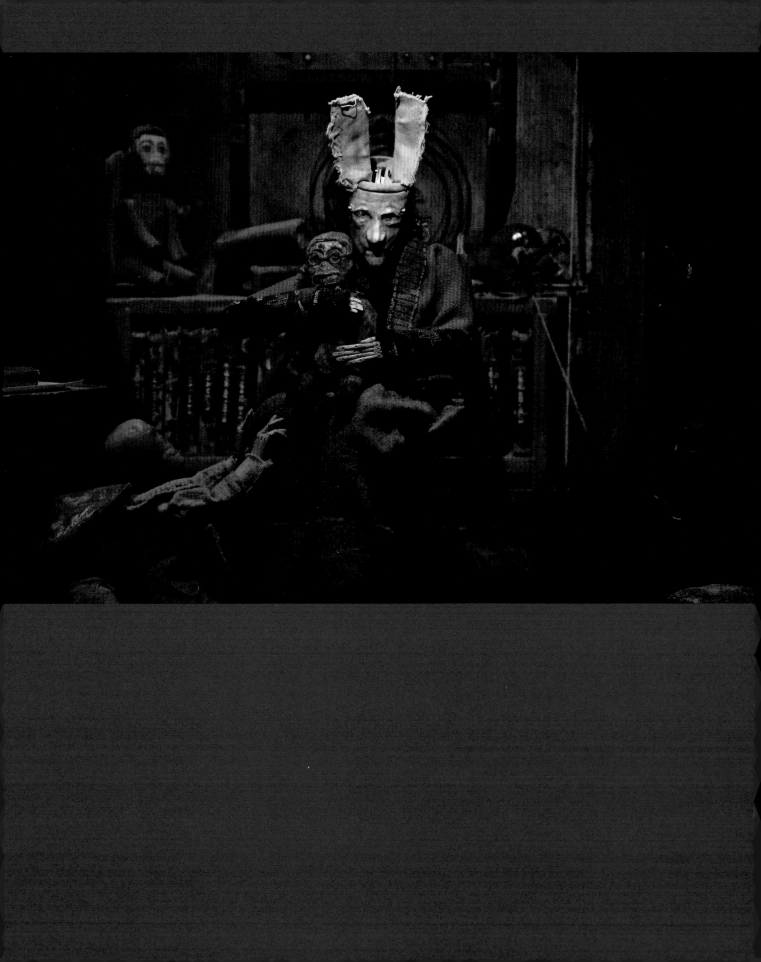

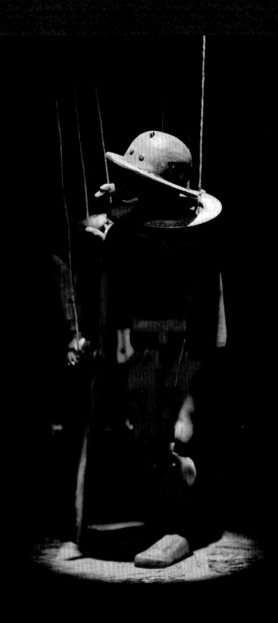

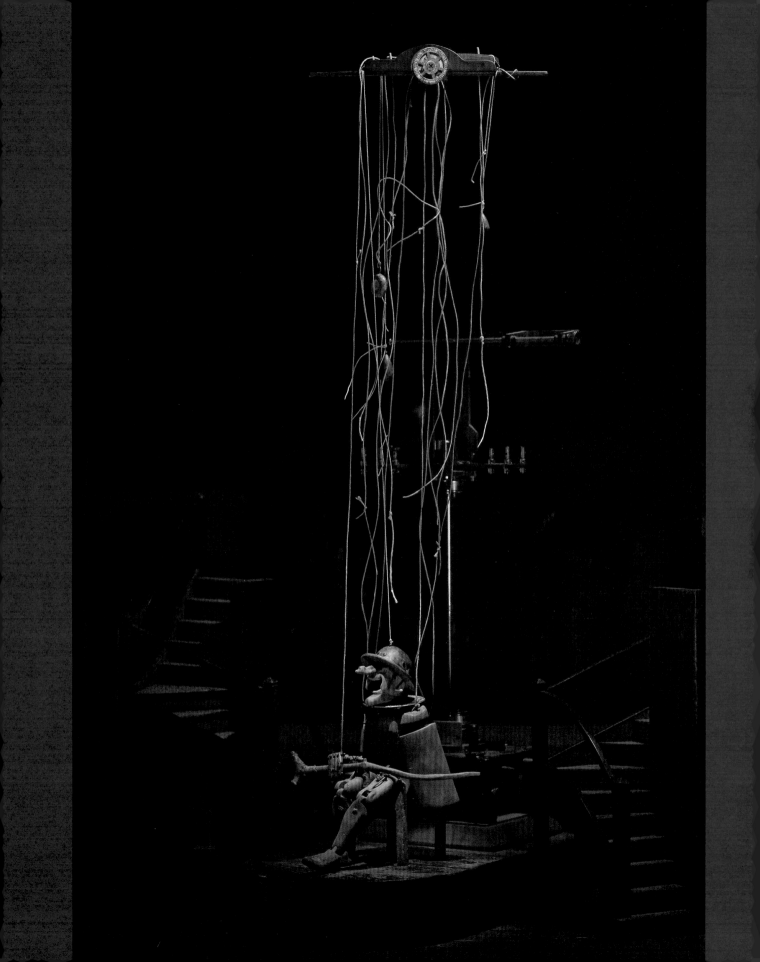

ARCUS NARRATING THE TALE

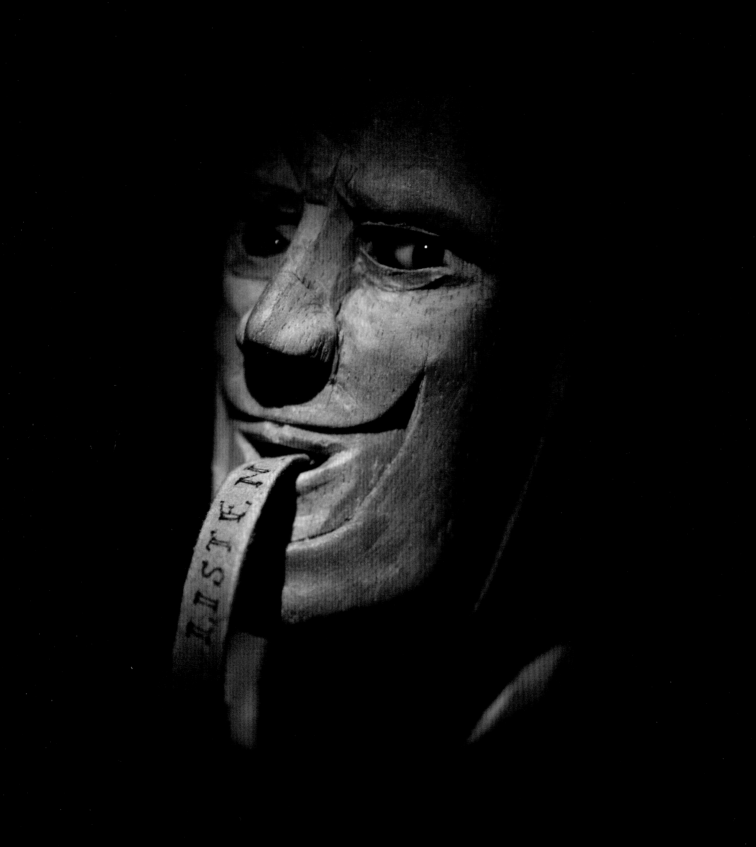

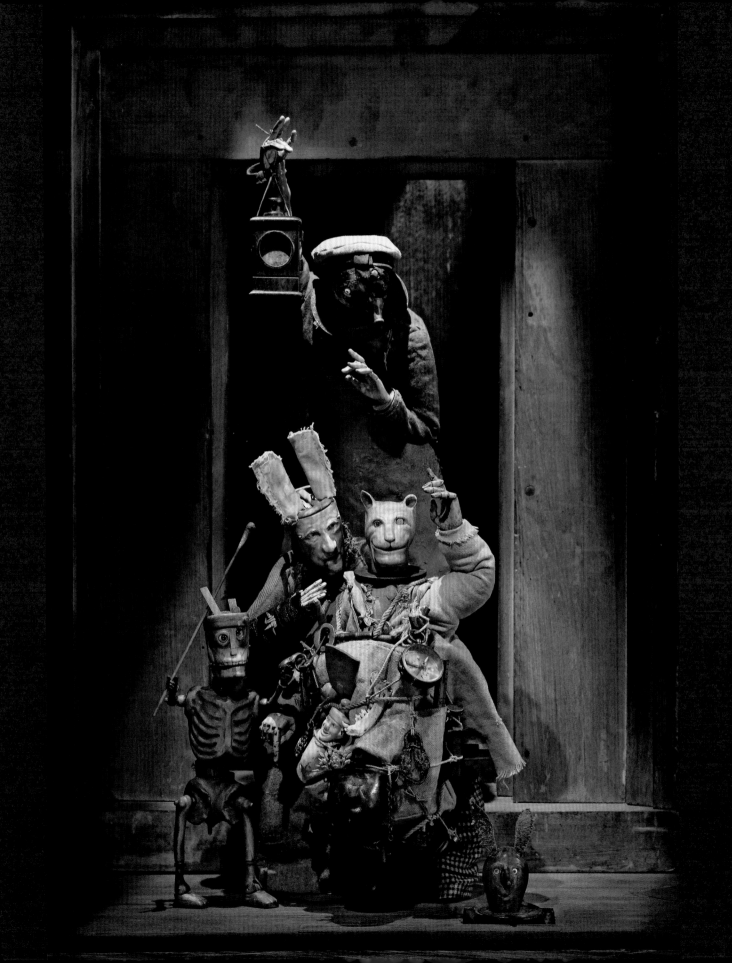

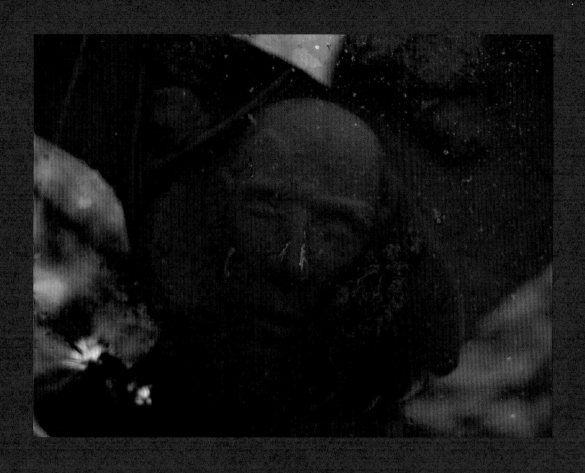

PERE JULES, MR. R, CAT V,
D'ARTAND, AND POM EXIT

FROM THE BOY'S THIRD DREAM

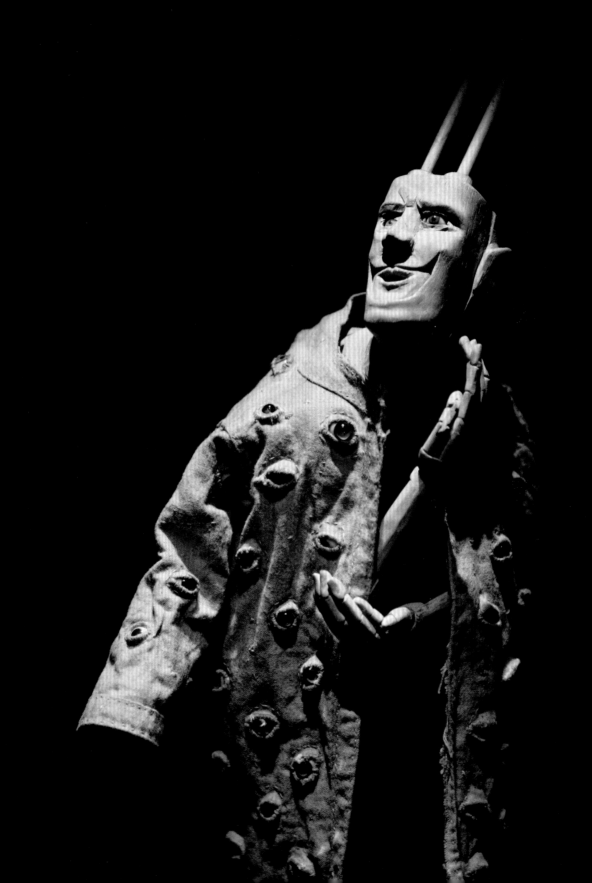

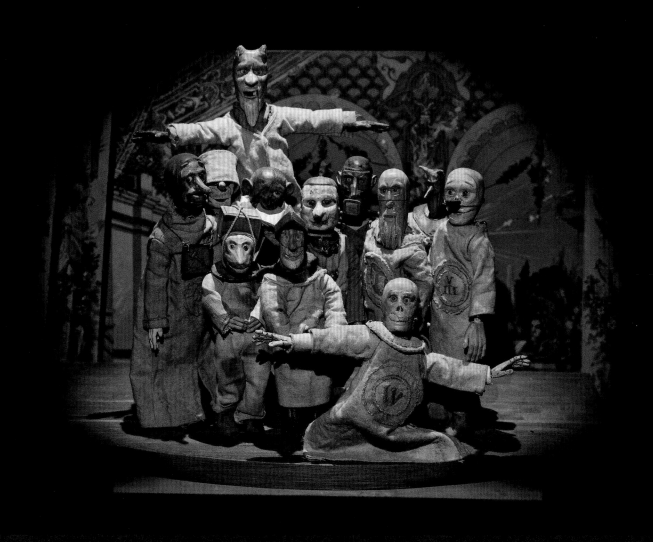

THE TOTTENTANZERS STRIKE A POSE

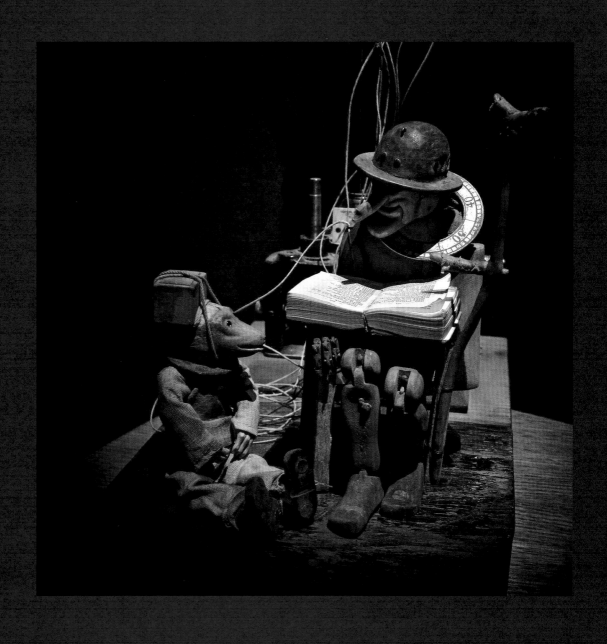

CBO READING TO WAD FROM
"THE BEEHIVE AND THE WINDMILL"

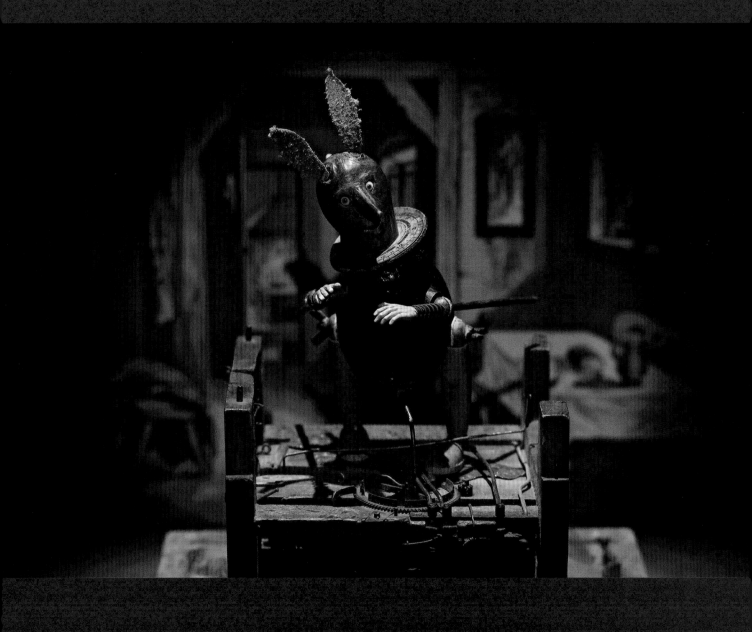

POM IN THE SILHOUETTE CUTTER'S HUT

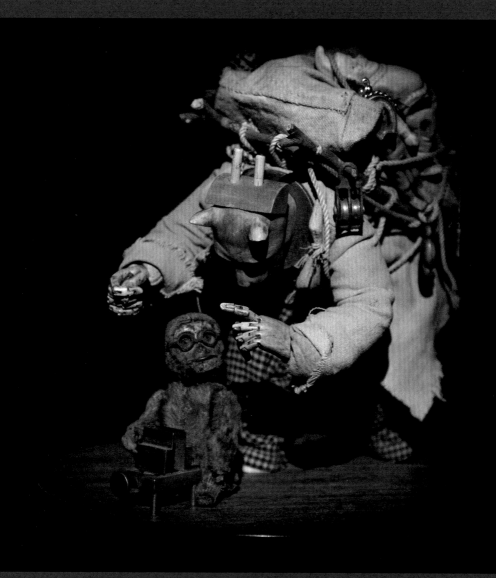

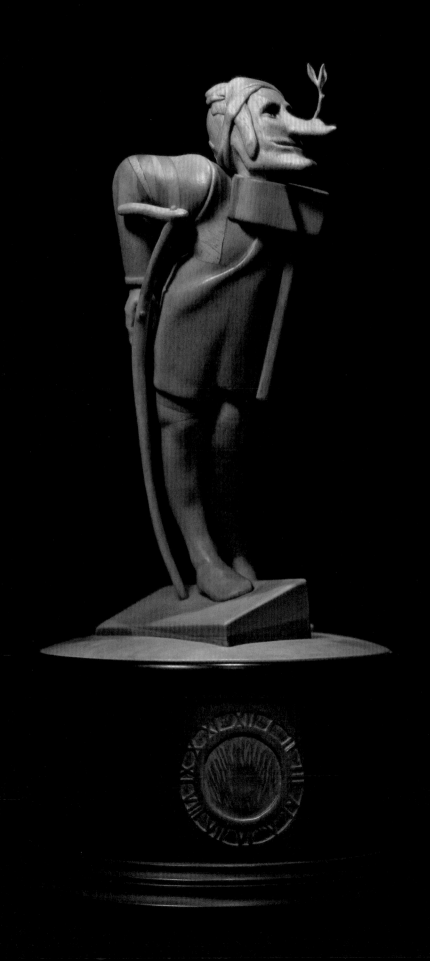

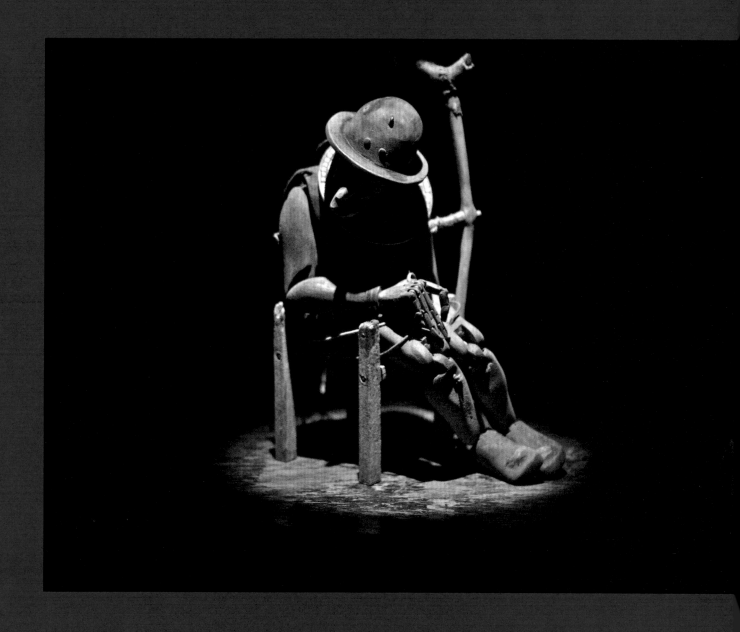

THE CRIPPLED BOY AS A MONUMENT CBO NEAR THE END OF THE PLAY

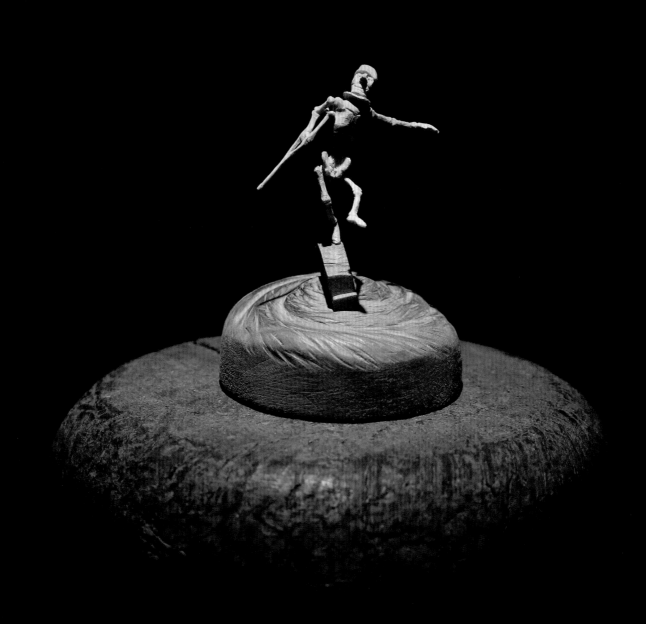

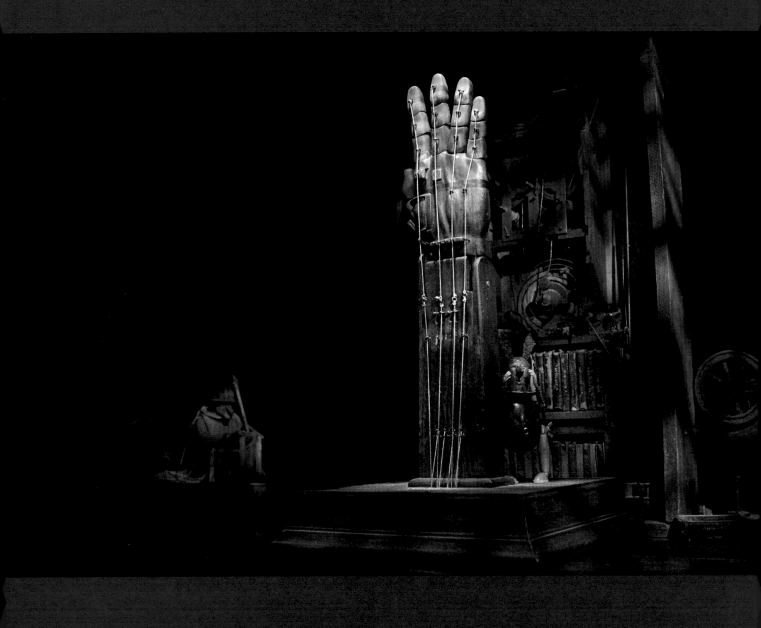

POM EXAMINES GLEYOT WHILE CBO LOOKS ON

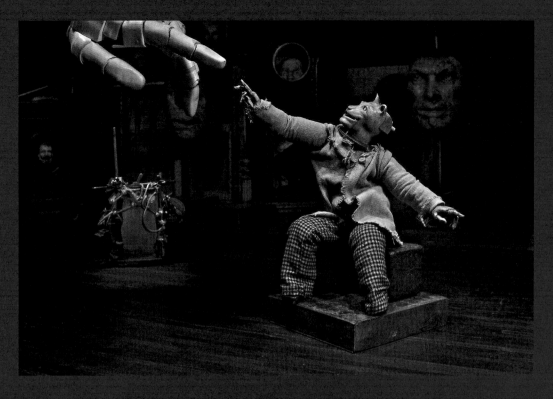

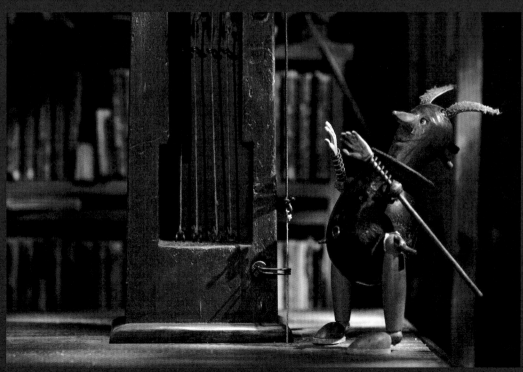

POM DISCOVERS GLEYOT

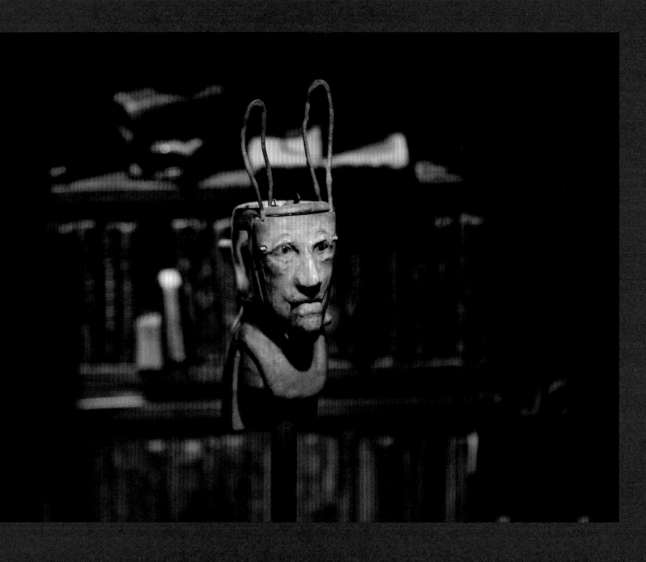

MR. R (ANIMATION STILL) MR. R IN THE PORTICO

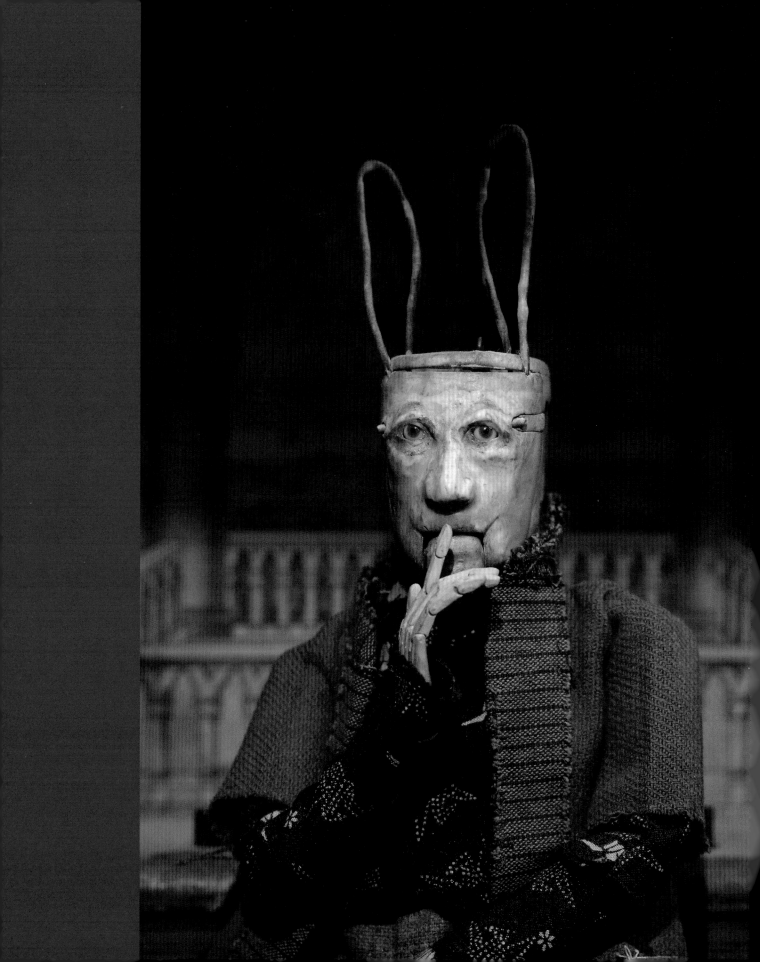

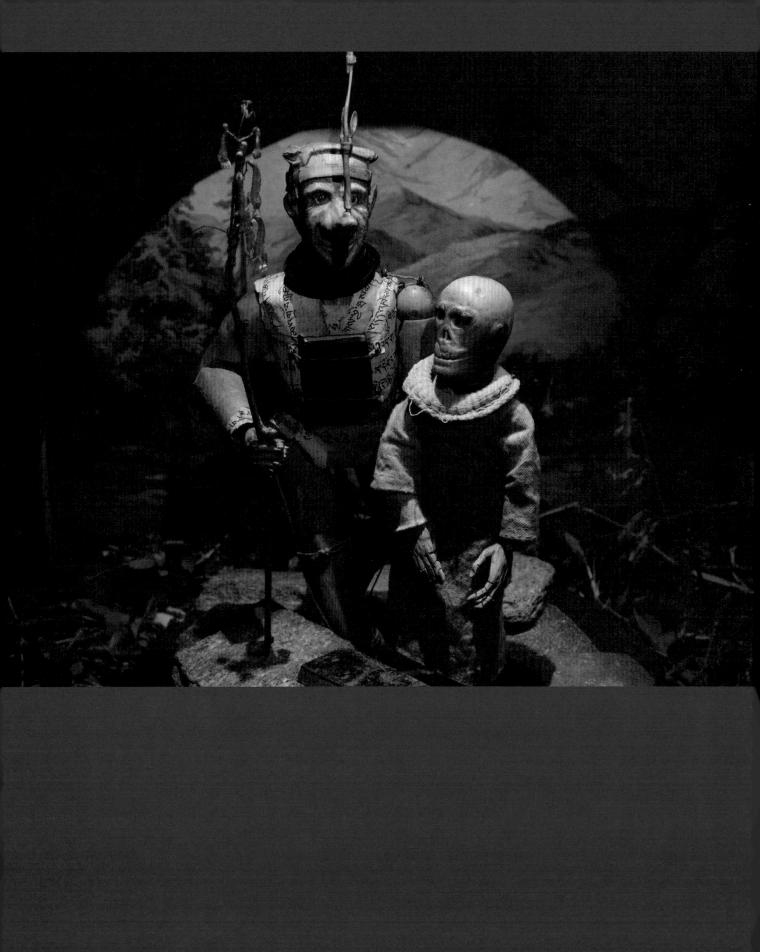

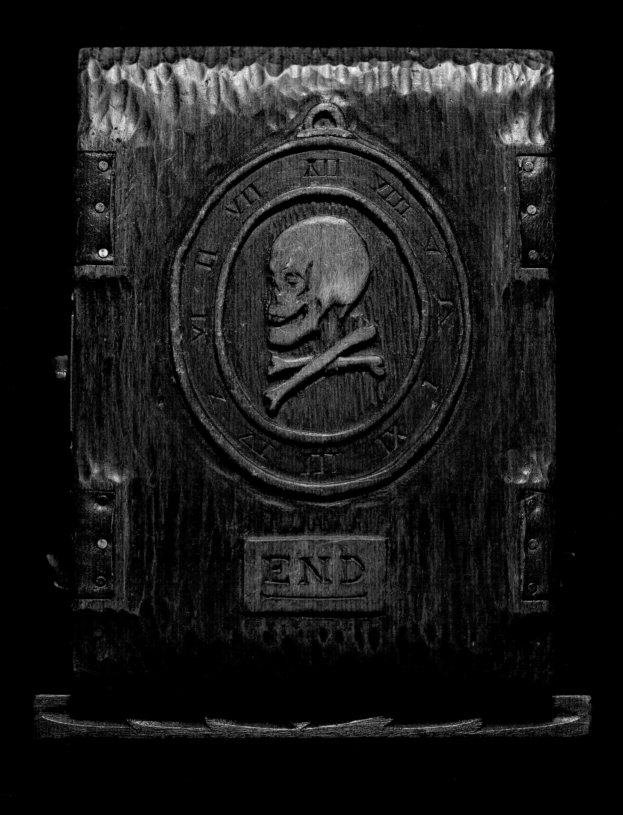

CAST OF CHARACTERS

All sculptures were created between 2006 and 2010. Dimensions are height by width by depth in inches and are for the figures only, except where otherwise noted. Measurements are rounded to the closest half inch.

The Crippled Boy/CB/The Boy
15 × 8 × 8 including permanent base
Wood
Static figure with twig on nose
This is the story's missing protagonist
and the first piece completed for
the project

Cat V
12 × 8 × 7
Wood, fabric, glass eyes, and found
objects over stainless steel armature
Catlike head in hound's-tooth pants
with pack on back

Pombolino or *Pom*
7 × 6 × 5
Case measures 23 × 20 × 10
Wood, glass eyes, and found objects
Small round-bellied figure with floppy
leather ears

Mr. R
16 × 6 × 4
Wood, fabric, glass eyes, and found
objects over stainless steel armature
Main character with tall ears in the
library setting with monkey

Pere Jules
23 × 7 × 7
Wood, fabric, leather, and found
objects over stainless steel armature
Figure in blue with leather apron,
oar, lantern, and topsy-turvy head

CB Miniature Skeleton Version:
CB Before Birth and After Death
3½ × 1½ × 1½
Case measures 23 × 20 × 10
Wood
Miniature wooden skeleton

O–Man
24 × 20 × 20 including attached base
Wood, glass eyes, and found objects
Figure with "Telescope" on round base
with planets

Scratch
14 × 12 × 15 including attached base
Wood, faux fur and feathers, gypsum,
bronze, and found objects
Devil-like figure in faux animal skin
on mechanized base

Hand of the Maker
11 × 6 × 6 including base and bell jar
Wood, glass, and found objects
Small articulated hand mounted in
bell jar

The Crippled Boy Old/CBO
32 × 9 × 16 including attached base
Wood, wire, cord, and found objects
Puppet-like figure on long base with
string support armature extended above

Narrator/Maker's Hand, also known
as *Gleyot*
23 × 13 × 13
Wood, wire, cord, and lead
Large, mechanical right hand—brown

Narrator/Makers Twin Hand, also
known as *Gleyot's Mate*
18 × 10 × 10
Wood and found objects
Large mechanical left hand—white

Argus
21 × 9 × 7
Wood, fabric, glass eyes, and found
objects over stainless steel armature
Tall figure in hundred-eye coat

Mechanical Head
22 × 17 × 14 including case
Wood, fabric, glass eyes, and found
objects
Mechanized head in scientific
"specimen" case

D'Artand or *Petit Mort with Hare Relief*
Carving on Easel
16 × 10 × 12 including attached bases
Wood, glass eyes, and found objects
Skeleton-like figure with torch

Tottentanzer 1: Scratch's Cousin Ingmar
11 × 3 × 2
Wood, fabric, and glass eyes
Tall Devil

Tottentanzer 2: Pip
8 × 3 × 2
Wood, fabric, glass eyes, and found
objects
Appears with bed—IV on coat

Tottentanzer 3: The Nautician
7 × 3 × 2
Wood, fabric, glass eyes, and found
objects
Also, *Ahab* or *The Little Steersman*—
VI on coat

Tottentanzer 4: Wag
7 × 3 × 2
Wood, glass eyes, and found objects
In red coat with blue pants—no number
on coat

Tottentanzer 5: St. M
8 × 3 × 2
Wood, fabric, glass eyes, and
found objects
Bearded with divided head—
II on coat

Tottentanzer 6: Wad
7 × 3 × 2
Wood, fabric, glass eyes, and
found objects
Demure figure with box on head—
no number on coat

Tottentanzer 7: Bucket
8 × 3 × 2
Wood, fabric, glass eye, and
found objects
One-eyed monkey standing in
a bucket—I on coat

Tottentanzer 8: Ashbutton
7 × 3 × 2
Wood, fabric, glass eyes, gold leaf,
and found objects
Gold sailor hat—X on coat

Tottentanzer 9: Fr. Anpheme
8 × 3 × 2
Wood, fabric, glass eyes, and
found objects
Russian ring hat—XI on coat

Tottentanzer 10: Doctor Subtilis
8 × 3 × 2
Wood, fabric, glass eyes, and
found objects
Blue eyes and wired-on nose—
VIII on coat

Tottentanzer 11: Baffle
8 × 3 × 2
Wood, fabric, glass eyes, and
found objects
Megaphone in mouth—III on coat

Tottentanzer 12: Deus Sod
9 × 6 × 7
Wood and hand-colored bronze
Upper torso of figure with raised
arm in wooden alcove

Tottentanzer 13: Plog / Bozuken
8 × 3 × 2
Wood, fabric, glass eyes, and
found objects.
Cowl, big nose, big mouth—
V on coat

Female Pierced / Milagro Torso
12 × 15 × 7 including case
Wood and found objects
Figure in Welsh clock case

Transit / Milagro Torso
15 × 11 × 7 including case
Wood and found objects
Figure with tree growing through
it, in transit case

Palace of Sleep
11½ × 12 × 8
Wood, stone, and found objects
A bed

*The Crippled Boy: Middle Period,
On the Heath*
12 × 6 × 3
Wood, wire, paper, cord, glass eyes,
and found objects
Figure with long twig on nose in
Sanskrit shirt

Osep Naz
9½ × 7 × 4
Wood, fabric, found objects, and
stainless steel armature
Figure in embroidered purple velvet
smoking jacket

Messenger and Charge
23 × 36 × 8
Wood and found objects
Large boat with two figures on board

Tale of the Crippled Boy Notebox
6 × 5 × 3½
Wood, found objects, colored pencil
on paper drawings affixed inside lid,
paper enclosures
Small, dark box with oval relief on top

Credo Notebox
6 × 9 × 3
Wood and leather with paper enclosures
Relief-carved clamshell box

Large Casket
6 × 15 × 12½
Wood, found objects, and paper
enclosures
Container for all of the artist's notes
and sketches for the project

Various set elements including the main
stage, smaller stages, masks, carved
heads, cases, and found objects that will
provide background on the main stage
and in the satellite areas

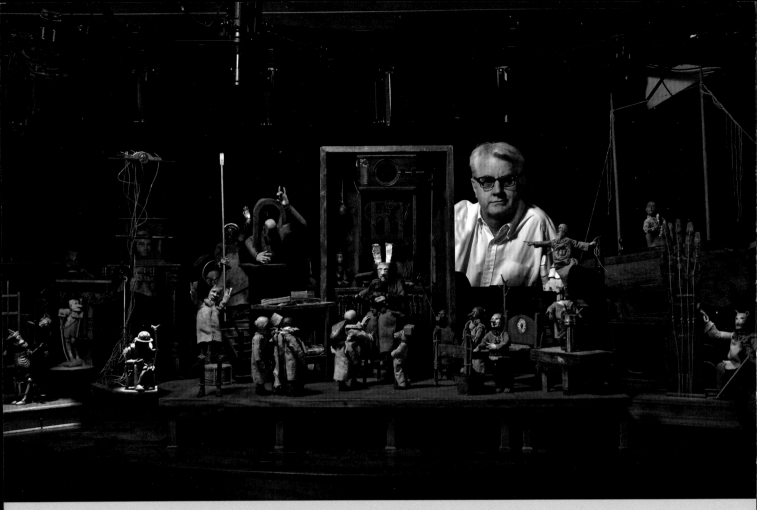

JOHN FRAME WITH THE CAST OF POOR TOM'S LIBRARY

Published in conjunction with the exhibition
*Three Fragments of a Lost Tale: Sculpture and Story
by John Frame,* March 12 through June 20, 2011

Copyright © 2011 The Huntington Library,
Art Collections, and Botanical Gardens
All rights reserved. No portion of this publication
may be reproduced without the written permission
of the publisher.

Second printing, 2011

Cataloging-in-Publication Data is on file with the
Library of Congress
ISBN 978-0-87328-245-1

Published by The Huntington Library,
Art Collections, and Botanical Gardens
1151 Oxford Road
San Marino, CA 91108
 www.huntington.org

Distributed by University Of California Press
 www.ucpress.edu

Front cover: Detail of *Mr. R in the Portico*
Back cover: *Pip and the Tottentanzers in Front
of the Gate of Desire*
Details on pages 3, 14 & 18 from *Pip and the
Tottentanzers in Front of the Gate of Desire*
Page 1: Detail from base of *The Crippled Boy
as Monument*
Pages 2–3: *O-Man Searches the Past*
Pages 4–5: *Argus Asks a Question*
Pages 6–7: *The Crippled Boy: Middle Period*
Pages 8–9: *Monk Reading about the Upheaval*
Page 10: *Gleyot Sleeping*
Pages 30–31: Top view of the *Tale of the Crippled
Boy Notebox*

All photographs by John Frame except for the fol-
lowing:
Page 23: *John Frame Working in his Studio* by Carey
Haskell
Page 27: *John Frame Working with D'Artand* by
Johnny Coffeen
Page 95: *CBO Reading to Wad from "The Beehive and
the Windmill"* by Ashley Fennell
Page 112: *John Frame with the cast of Poor Tom's
Library* by Ashley Fennell

Produced by Marquand Books, Inc., Seattle
 www.marquand.com

Edited by Martin Fox
Designed by Zach Hooker
Typeset by Marissa Meyer
Color management by iocolor, Seattle
Printed and bound in China by C&C Offset Printing
Co., Ltd.